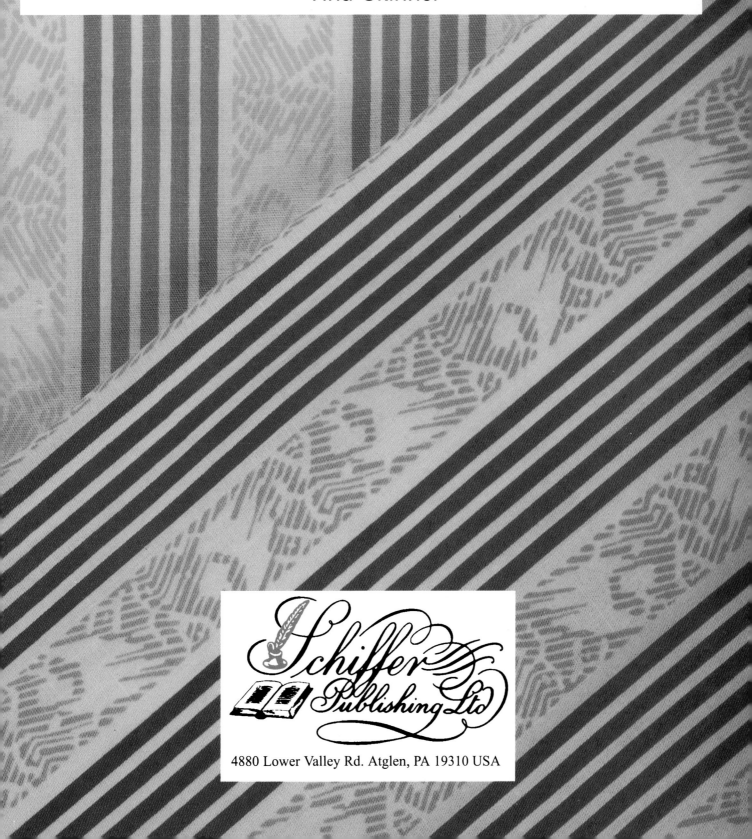

Stripes

A Survey of Fabric Designs
Tina Skinner

Schiffer Publishing Ltd

4880 Lower Valley Rd. Atglen, PA 19310 USA

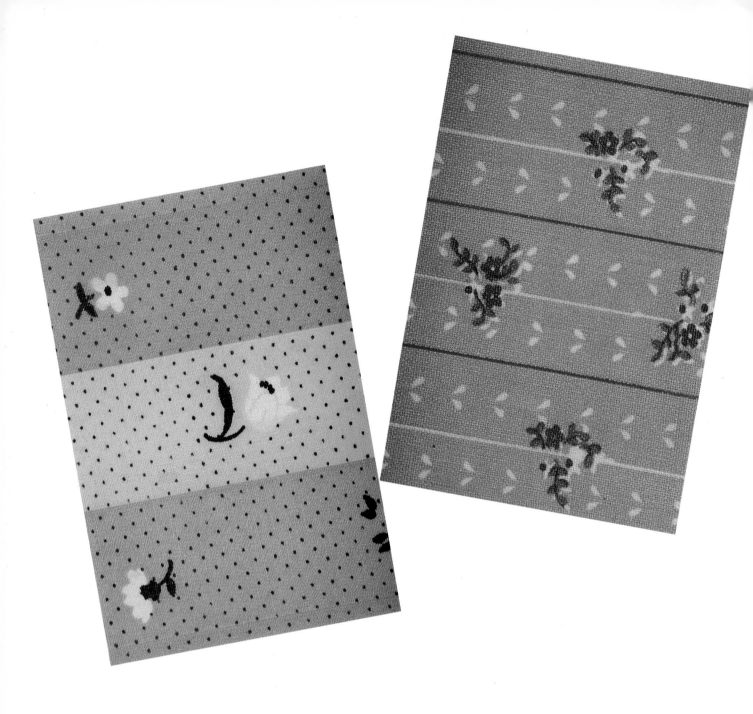

Designed by Bonnie M. Hensley

ISBN: 0-7643-0482-8
Printed in Hong Kong

Published by Schiffer Publishing Ltd.
4880 Lower Valley Road
Atglen, PA 19310
Phone: (610) 593-1777; Fax: (610) 593-2002
E-mail: schifferbk@aol.com
Please write for a free catalog.
This book may be purchased from the publisher.
Please include $3.95 for shipping.
Try your bookstore first.

We are interested in hearing from authors
with book ideas on related subjects.

Introduction

Stripes take on many forms, or one might say that many forms take on stripes. In researching thousands of historic fabric samples, we found nearly everything strung together to form stripes, from the ever-prevalent flowers and paisley, to the improbable swastikas and lemons. The convenience of stripes in repeating fabric patterns accounts for their ongoing popularity and the possibilities for designers are endless.

The stripe is as old as the loom in fabric design. This history, however, begins in the 1920s, and dwells mostly in the 1950s and '60s, eras that keep reemerging in popular art and fashion. The photos in this volume were gleaned from a large library of historic fabric swatches, primarily from the United States, France, and Italy. Since the photos are of swatches, they are only a small representation of designs for much larger pieces of cloth. Wherever possible, we have tried to picture an entire repeat, though usually it will be up to the viewer to use his or her imagination to complete the pattern. Also, the photos are vertically arranged to economically use space while showing the maximum area of cloth, so they aren't always true to the intended direction of the print. When known, fabric content and the country and date of origin are listed with the photographs to help provide historic reference.

This book presents a broad array of styles, from straight, standard dress-shirt stripes to artistic, irregular, wavy lines. There is a sampling of woven stripes, created on the loom, contrasted with prints that imitate the texture of weaves. There is an enormous representation of floral designs, intended both for ladies' fashions and for household use throughout the past seven decades, and a section devoted entirely to stripes which evoke the artist's original work, with painterly brushstrokes preserved. There is a section for striped brocades, another for polka dot designs, and another for zigzag creations. And then, because there is no other way to describe them, a concluding host of pictures devoted simply to the many whims and fancies of fabric designers throughout the years.

Conceived of as a source book of ideas, it is hoped that these patterns from the past will stimulate fresh ideas among fabric and clothing designers today and into the future.

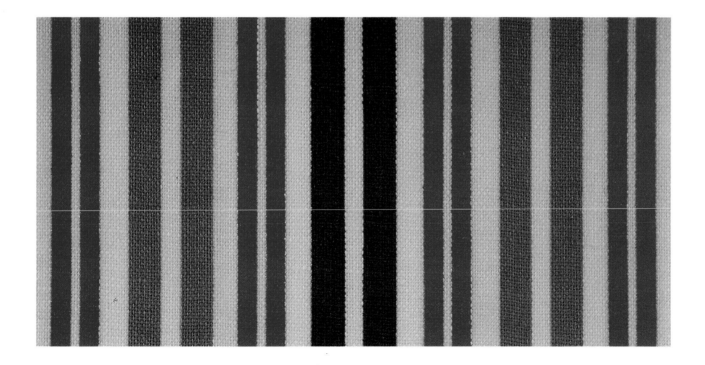

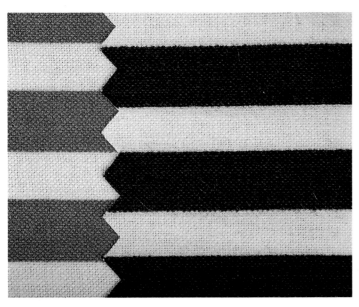 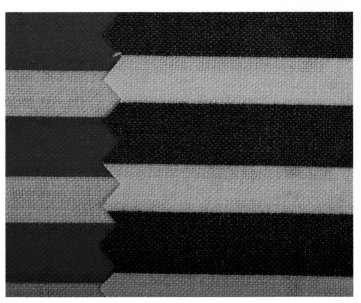

Cotton/rayon blend. USA. 1950s. Cotton/rayon blend. USA. 1950s.

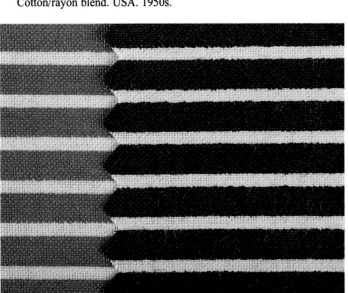 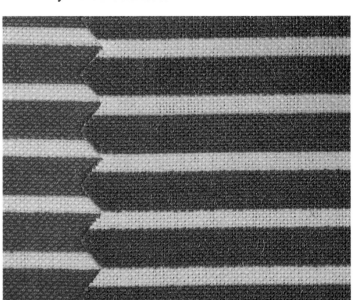

Cotton/rayon blend. USA. 1950s. Cotton/rayon blend. USA. 1950s.
Polished Cotton. USA. 1959. Polished Cotton. USA. 1959.

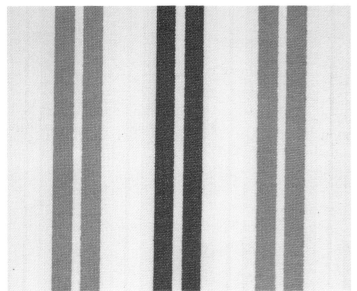 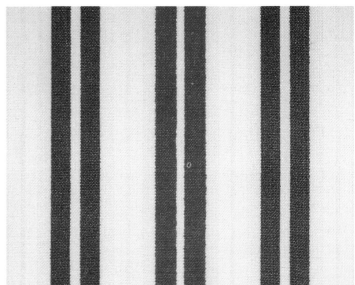

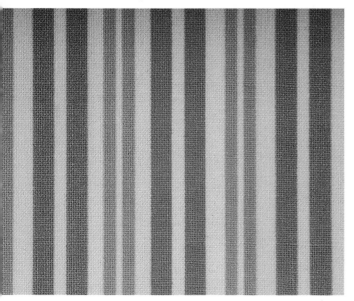
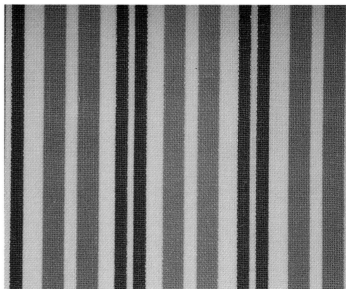

Cotton. USA. 1965. Cotton. USA. 1965.

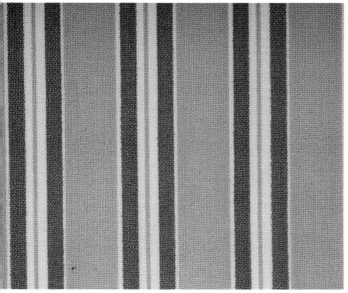
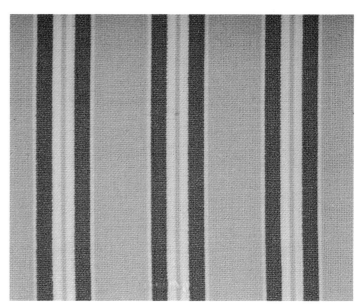

Cotton. USA. 1954. Cotton. USA. 1954.
Cotton. USA. 1954. Cotton. USA. 1954.

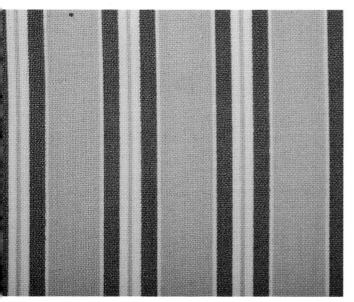
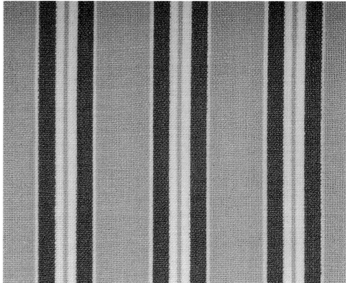

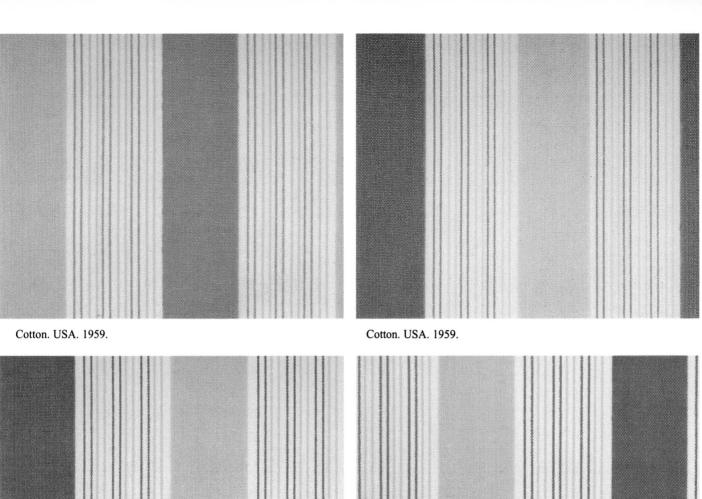

Cotton. USA. 1959.

Cotton. USA. 1959.

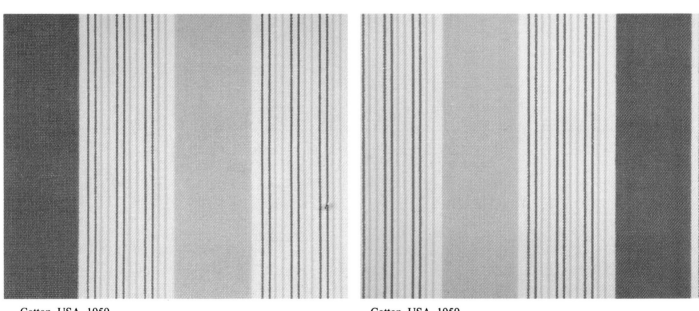

Cotton. USA. 1959.

Cotton. USA. 1959.

Cotton. USA. 1959.

Cotton. USA. 1959.

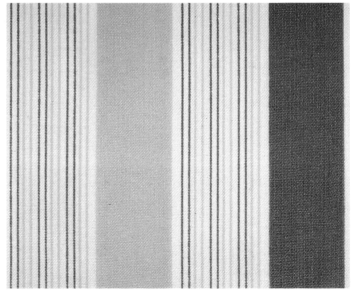

Cotton. USA. 1959.

Cotton. USA. 1959.

Cotton. USA. 1954.

Cotton. USA. 1954.

Cotton. USA. 1954.

Cotton. USA. 1954.

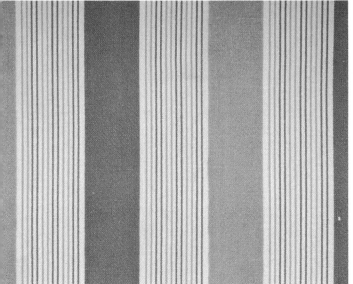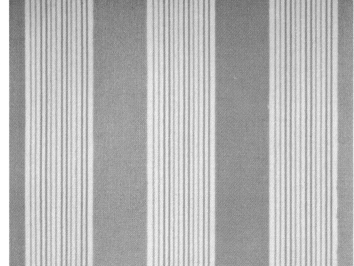

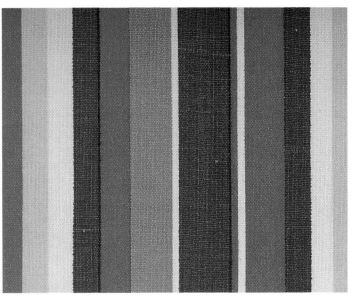

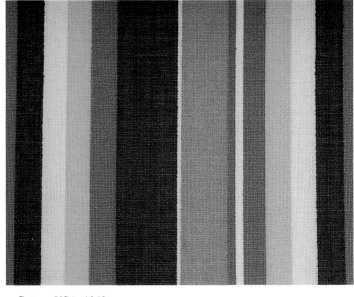

Cotton. USA. 1942.

Cotton. USA. 1942.

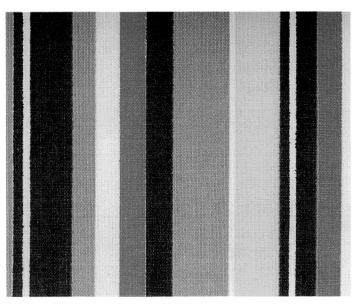

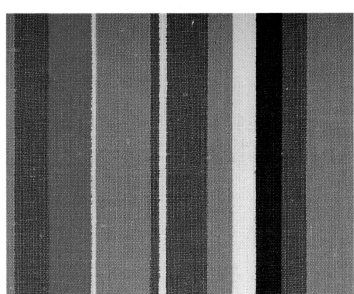

Cotton. USA. 1942.
Cotton. USA. 1942.

Cotton. USA. 1942.
Cotton. USA. 1942.

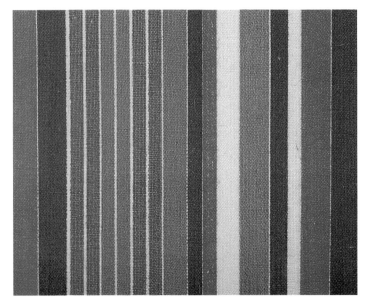

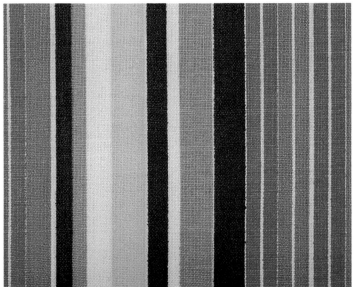

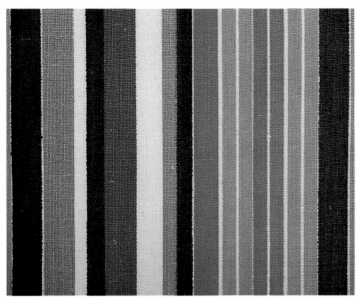

Cotton. USA. 1942.

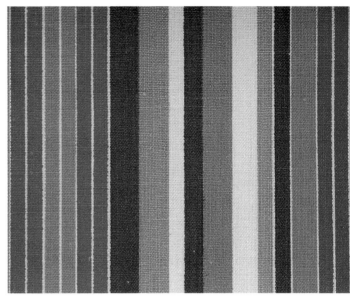

Cotton. USA. 1942.

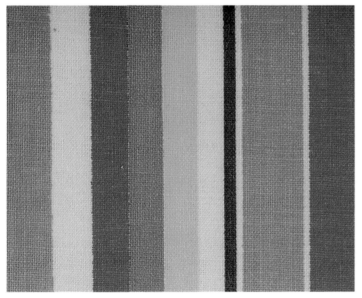

Cotton. USA. 1942.
Cotton. USA. 1942.

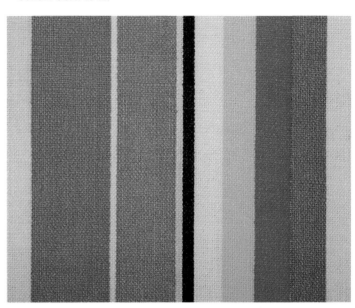

Cotton. USA. 1942.
Cotton. USA. 1942.

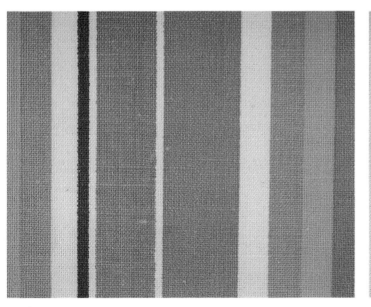

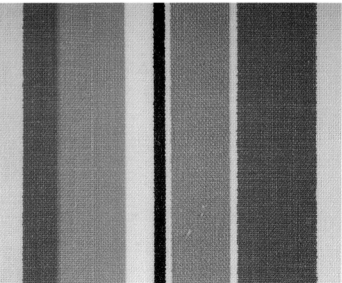

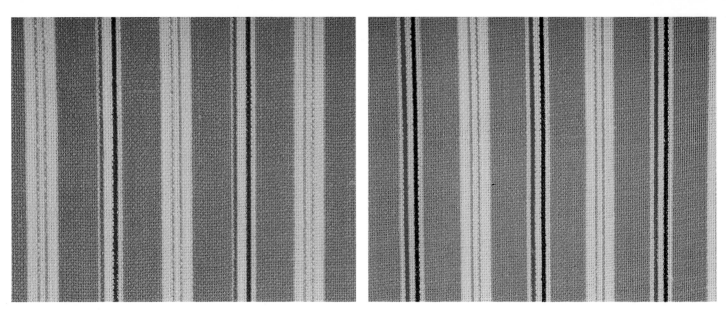

Cotton. USA. 1942.

Cotton. USA. 1942.

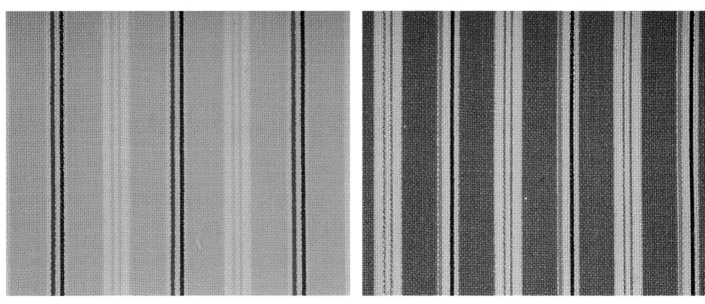

Cotton. USA. 1942.

Cotton. USA. 1954.

Cotton. USA. 1942.

Cotton. USA. 1954.

Cotton. USA. 1954.

Cotton. USA. 1954.

Cotton. USA. 1954.

Cotton. USA. 1954.

Cotton. USA. 1954.

Cotton. USA. 1954.

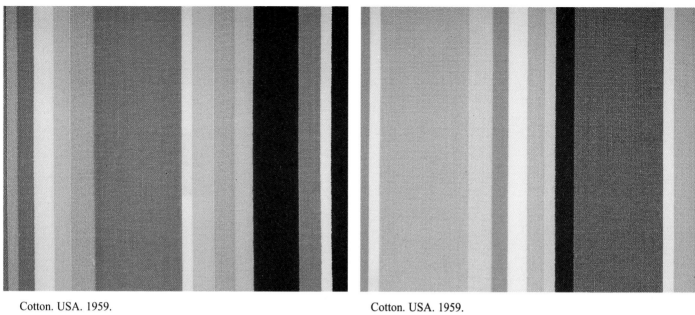

Cotton. USA. 1959.

Cotton. USA. 1959.

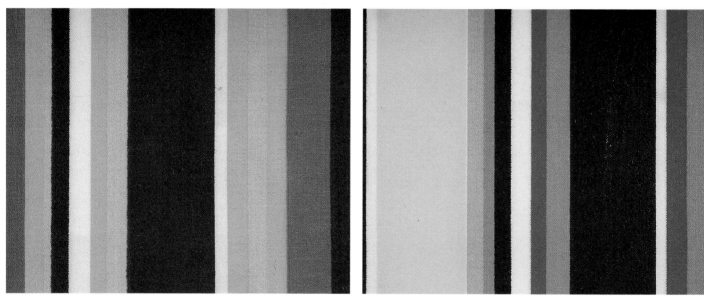

Cotton. USA. 1959.
Cotton. USA. 1948.

Cotton. USA. 1959.
Cotton. USA. 1948.

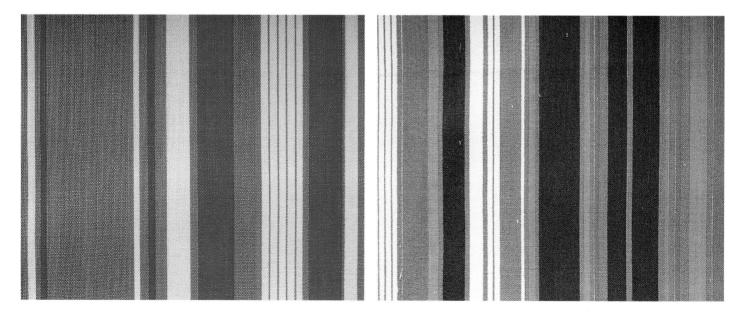

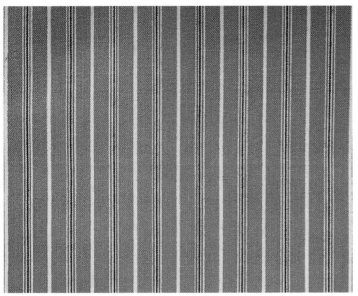

Cotton. USA. 1948.

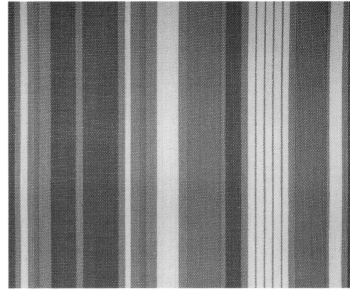

Cotton. USA. 1948.

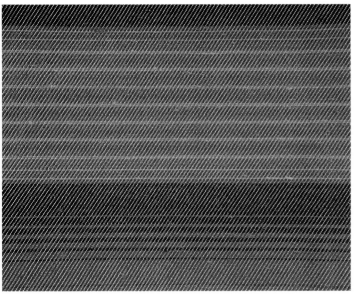

Rayon/nylon. USA. 1980s.
Rayon/polyester. USA. 1980s.

Rayon/nylon. USA. 1980s.
Polyester/rayon. USA. 1980s.

Cotton. France. 1964.

Cotton. France. 1964.

Silk. France. 1964.

Cotton. France. 1964.

Silk. France. 1964.

Linen. France. 1964.

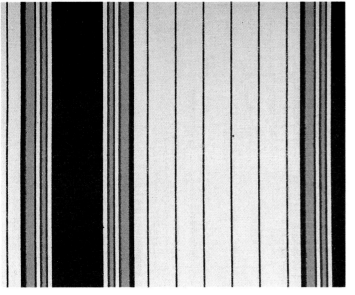

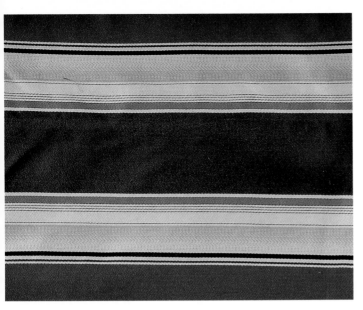

Rayon/polyester/cotton. USA. 1980s.

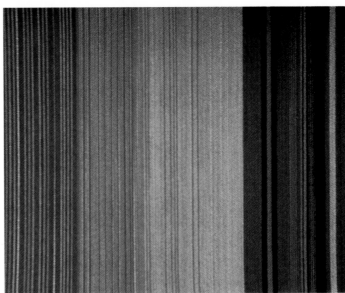

Polyester/acrylic/cotton. USA. 1980s.

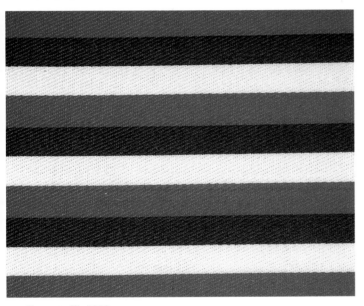

Cotton twill. 1950s.

Rayon. France. 1966.

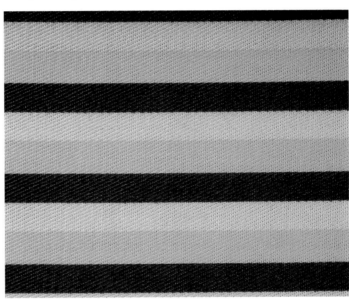

Cotton twill. USA. 1950s.

Cotton. USA. 1954.

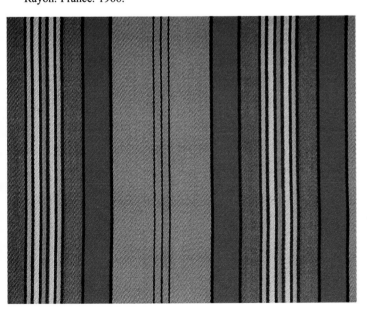

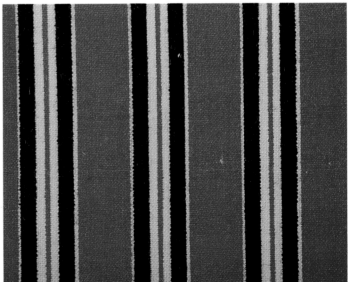

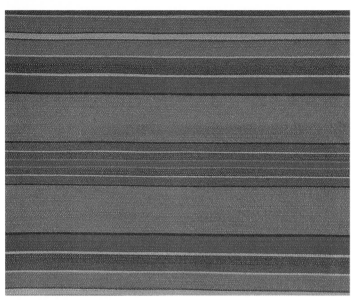

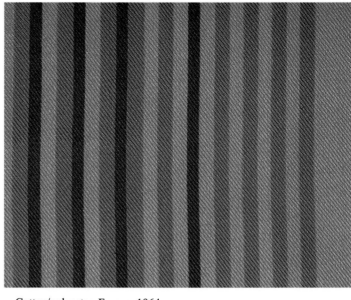

Spun rayon/polyester/cotton. USA. 1980s.

Cotton/polyester. France. 1964.

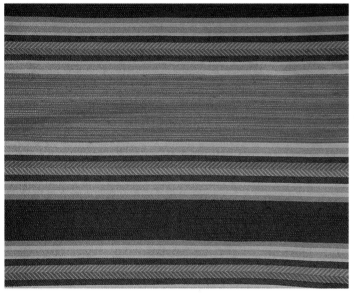

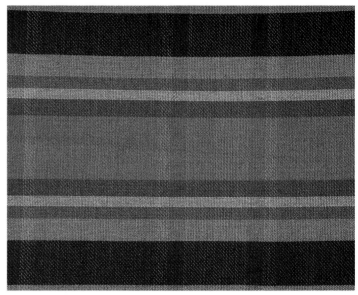

Polyester/cotton. USA. 1980s.
Cotton/rayon/linen. USA. 1980s.

Rayon/cotton/polyester. USA. 1980s.
Rayon/Polyester/cotton. USA. 1980s.

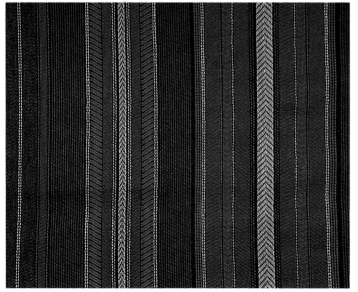

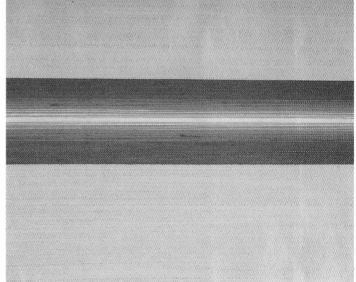

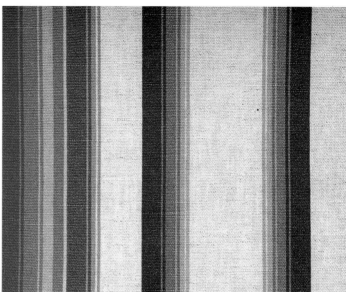

Silk. France. 1964.

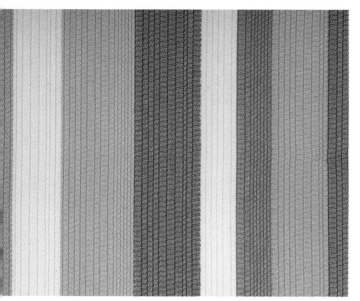

Olefin/polyester. USA. 1980s.

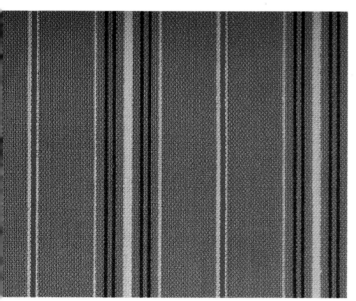

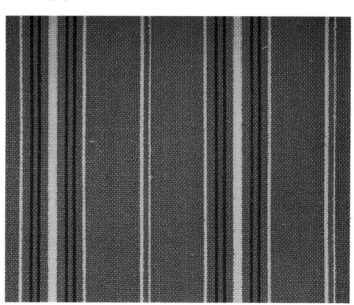

Cotton. USA. 1948.
Cotton/rayon. France. 1964.

Cotton. USA. 1948.
Silk. France. 1950s.

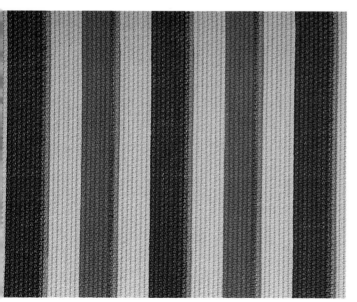

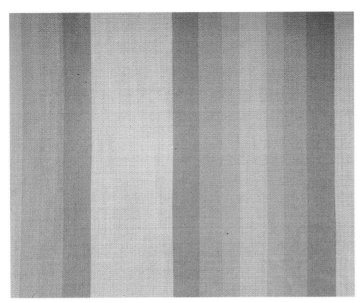

Rayon/nylon. USA. 1980s.

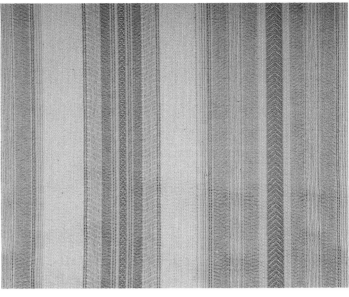

Olefin/polyester/rayon. USA. 1980s.

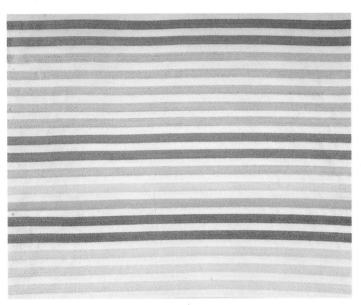

Polyester/acrylic/cotton. USA. 1980s.
Rayon/nylon. USA. 1980s.

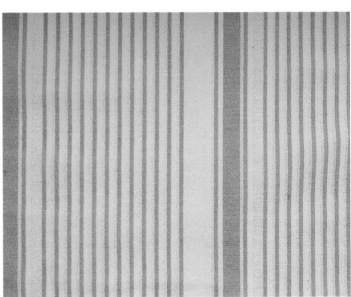

Combed cotton/acetate. USA. 1980s.
Spun rayon/polyester. USA. 1980s.

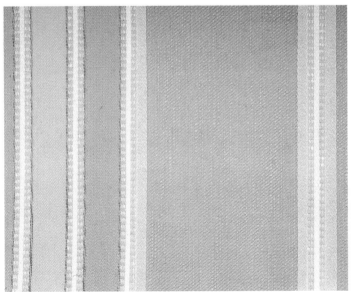

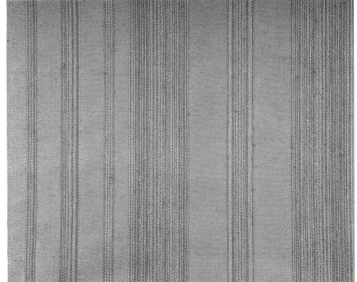

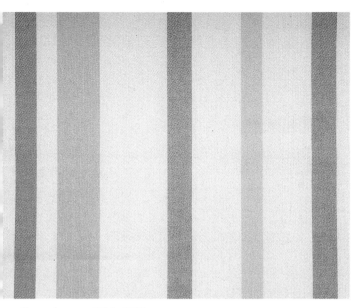

Cotton/acetate. USA. 1980s.

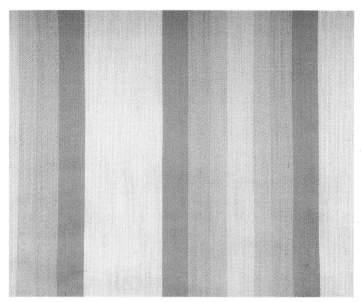

Polyester/cotton/acrylic. USA. 1980s.

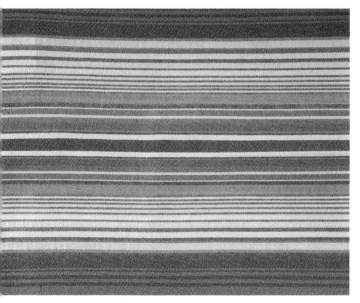

Rayon/polyester. USA. 1980s.
Polyester/rayon/cotton. USA. 1980s.

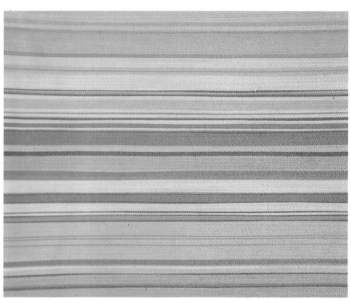

Rayon/polyester. USA. 1980s.
Polyester/rayon/cotton. USA. 1980s.

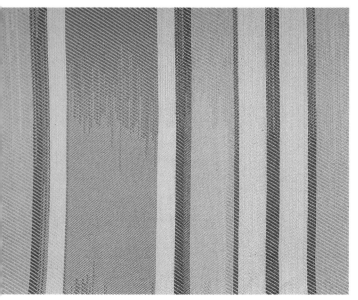

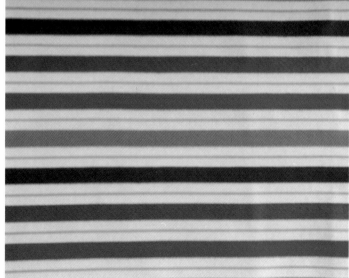

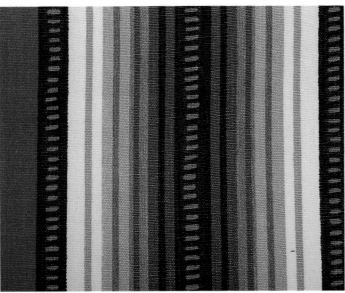

Cotton. France. 1962.

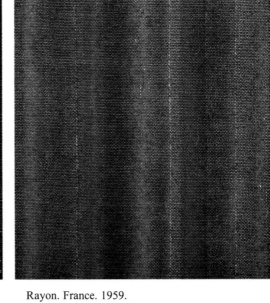

Rayon. France. 1959.

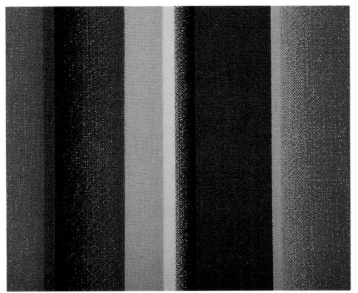

Cotton. France. 1963.

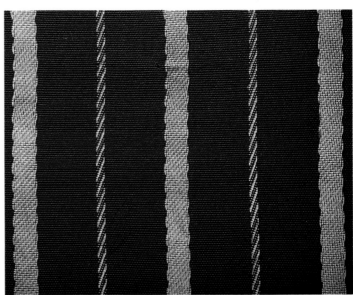

Polyester/cotton/rayon. USA. 1980s.

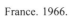

France. 1966.

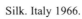

Silk. Italy 1966.

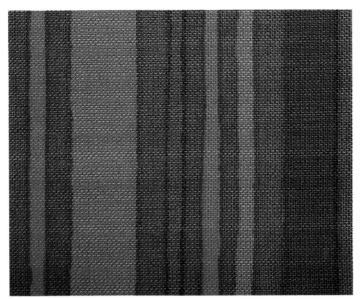

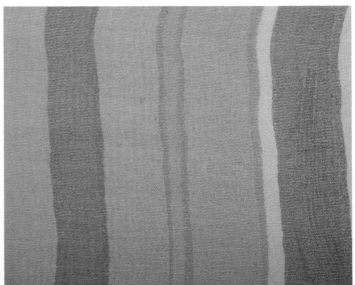

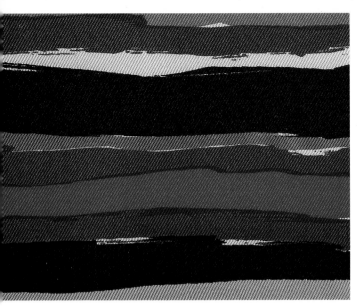

Silk. France. 1967.

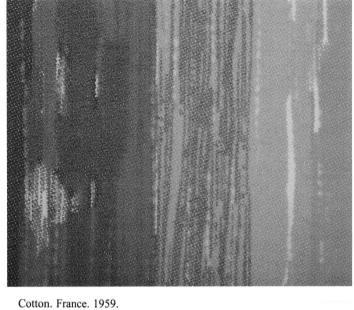

Cotton. France. 1959.

Linen. France. 1961.

Cotton/polyester. France. 1959.

Cotton. France. 1962.

Cotton. France. 1961.

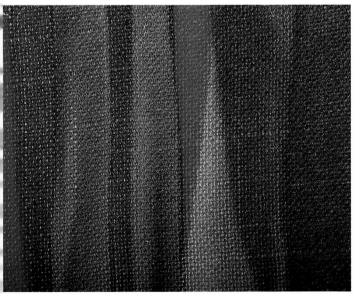

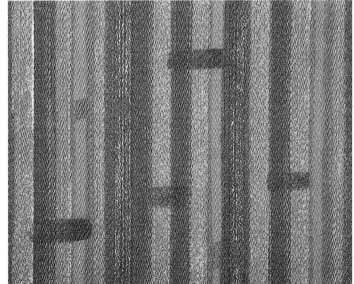

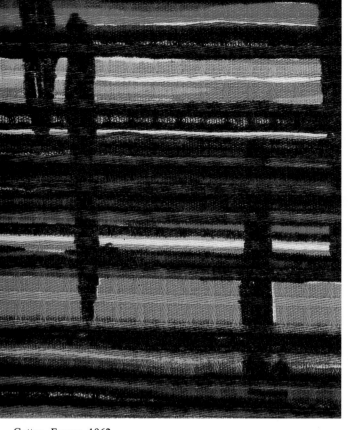

Cotton. France. 1962.

Cotton/polyester. France. 1964.

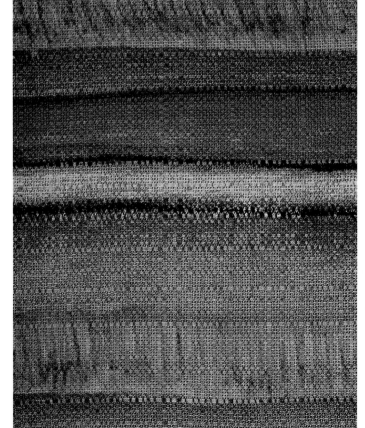

Linen/rayon. France. 1964.

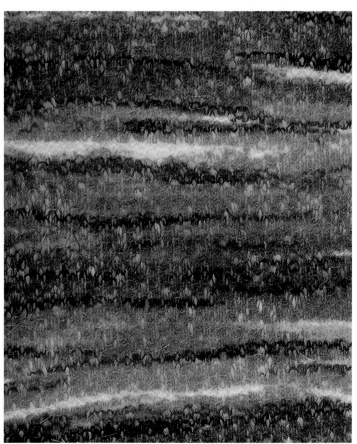

Polyester blend. France. 1964.

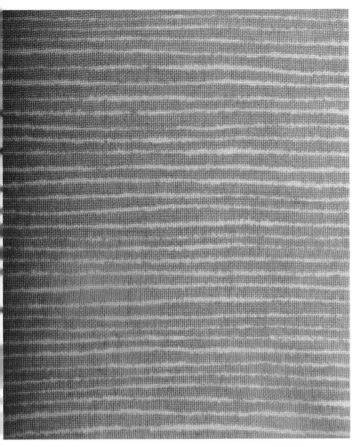

Cotton. USA. 1959.

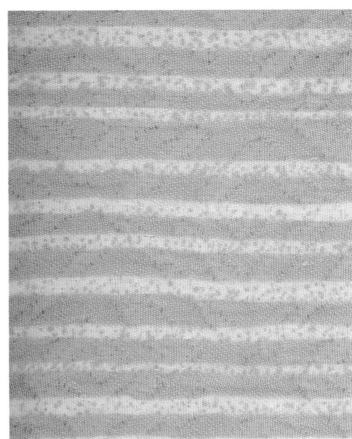

Quilted cotton/polyester. France. 1963.

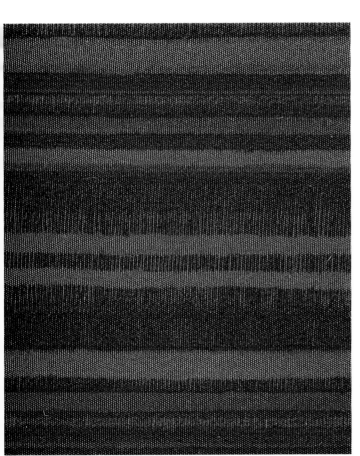

Cotton. France. 1961.

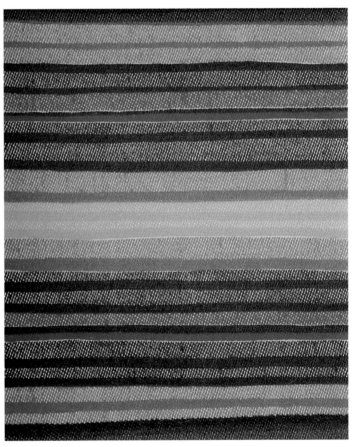

Cotton/polyester. France. 1963.

Acetate. Italy. 1966.

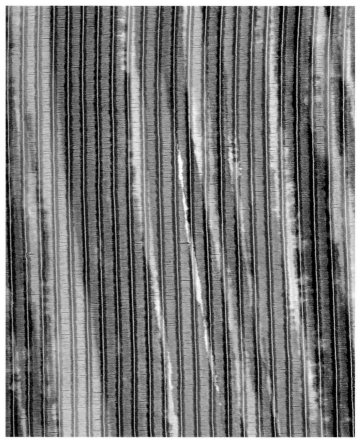

Silk. France. 1963.

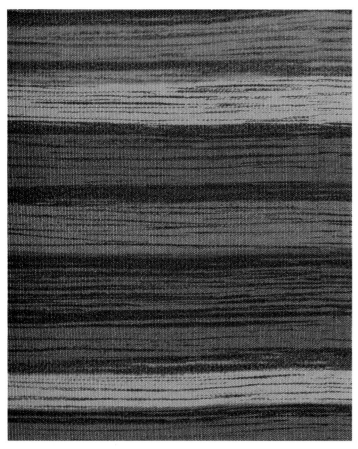

Cotton. France. 1963.

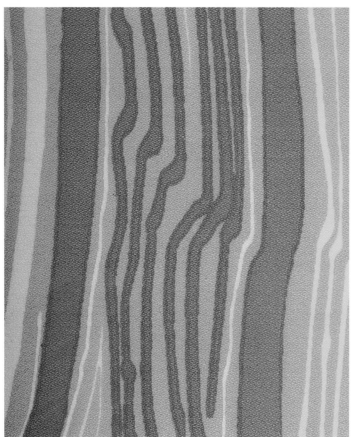

Rayon/cotton. France. 1962.

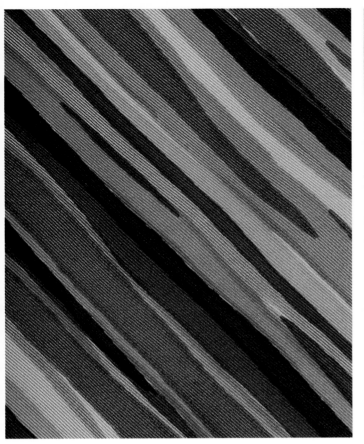

Silk. Italy. 1967.

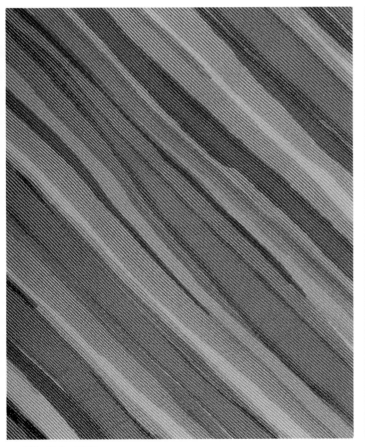

Silk. Italy. 1967.

Cotton/polyester. France. 1962.

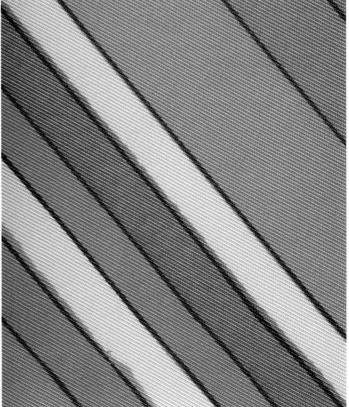

France. 1967.

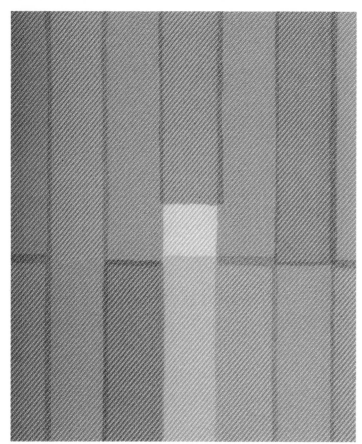

France. 1967.

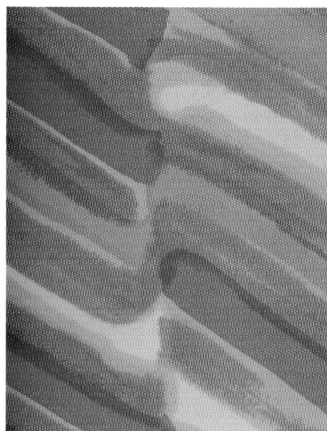

Cotton/polyester/rayon. France. 1963.

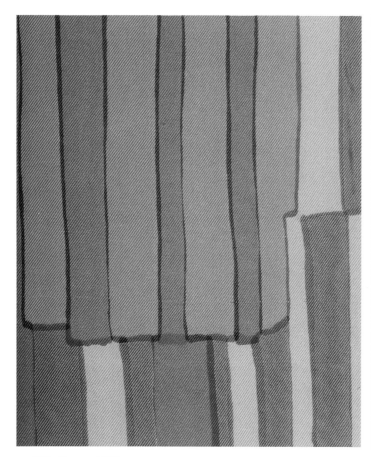

Silk. France. 1967.

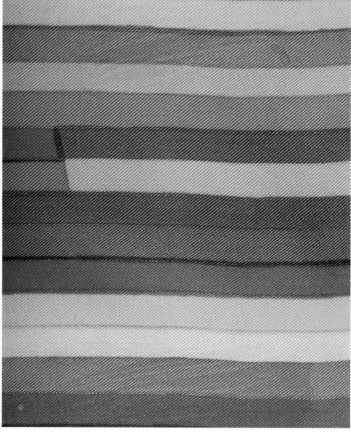

Silk. Italy. 1967.

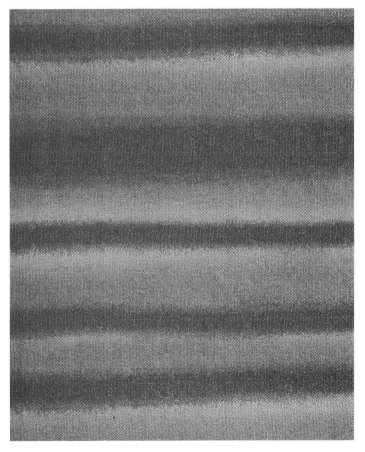

Cotton. USA. 1980s.

Cotton. France. 1964.

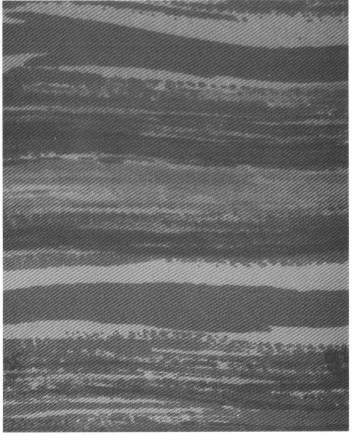

Silk. France. 1963.

Cotton/rayon. France. 1963.

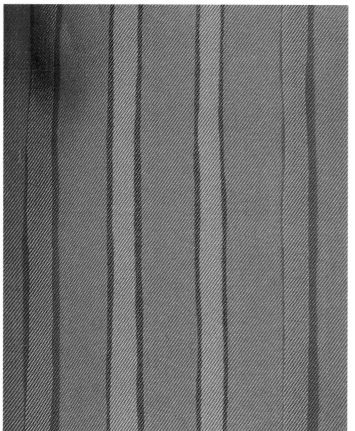

Silk. France. 1963.

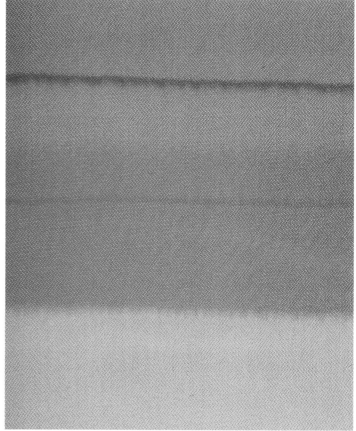

Silk. Italy. 1968.

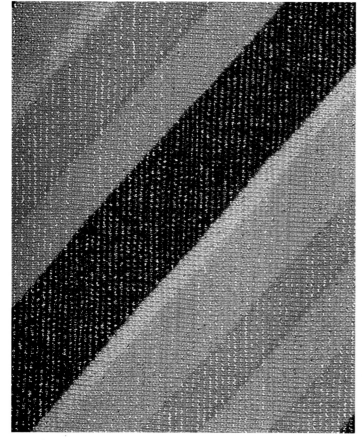

Polyester/silk. Italy. 1968.

Silk. France. 1963.

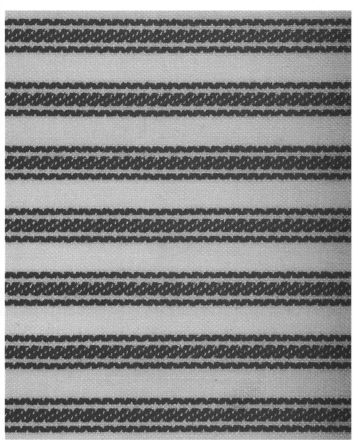

Cotton. USA. 1965.

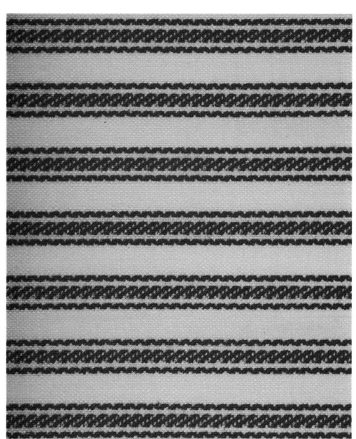

Cotton. USA. 1965.

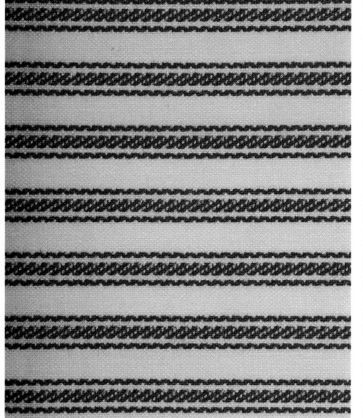

Cotton. USA. 1965.

Cotton. USA. 1965.

Cotton. USA. 1965.

Cotton. USA. 1965.

Cotton. USA. 1965.

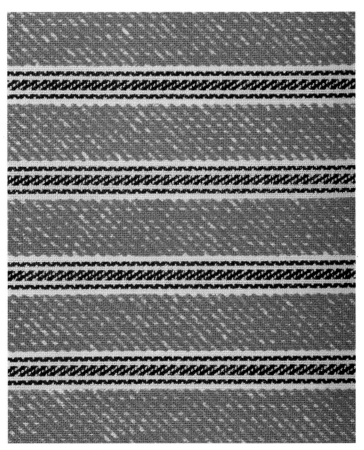

Cotton. USA. 1965.

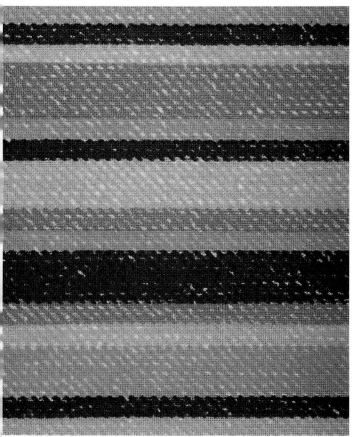

Cotton. USA. 1963.

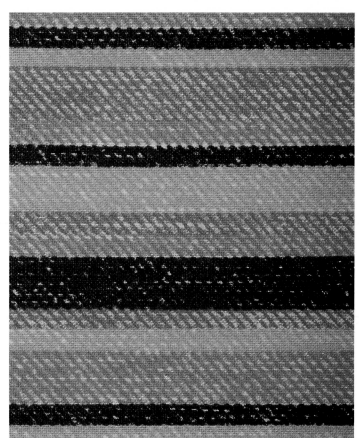

Cotton. USA. 1963.

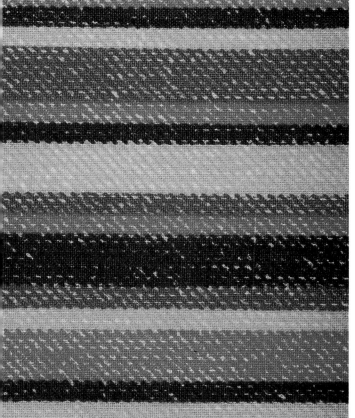

Cotton. USA. 1963.

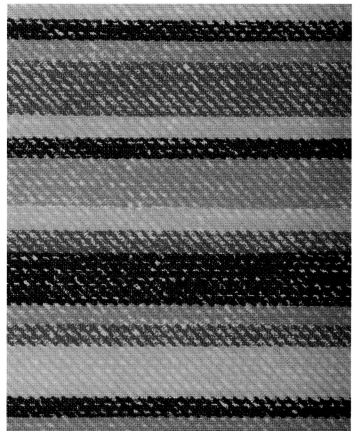

Cotton. USA. 1963.

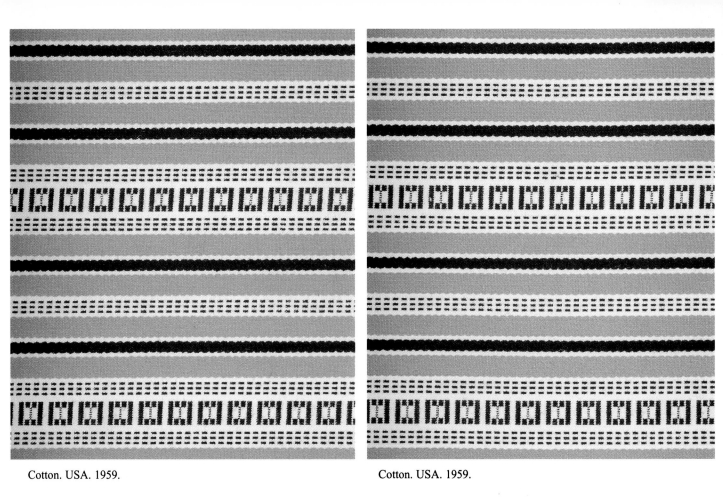

Cotton. USA. 1959.

Cotton. USA. 1959.

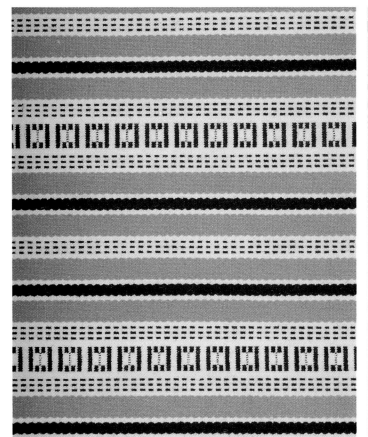

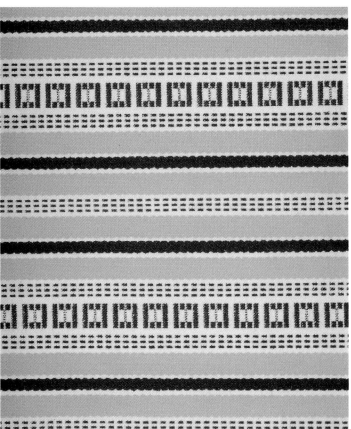

Cotton. USA. 1959.

Cotton. USA. 1959.

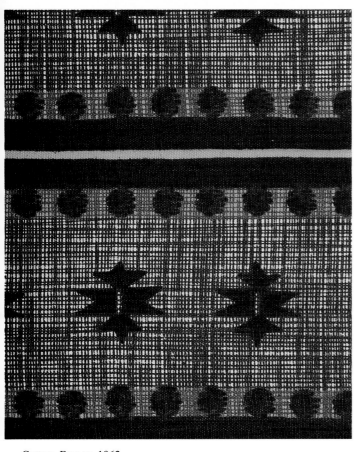

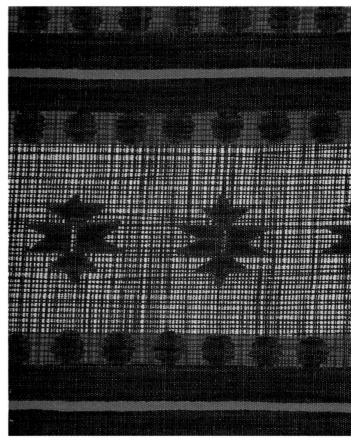

Cotton. France. 1962.

Cotton. France. 1962.

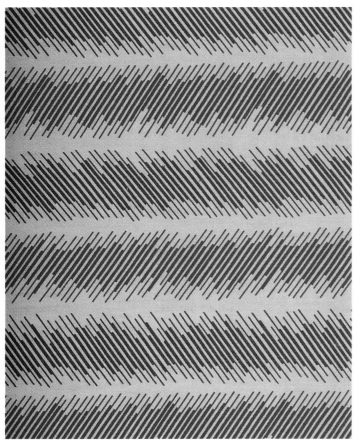

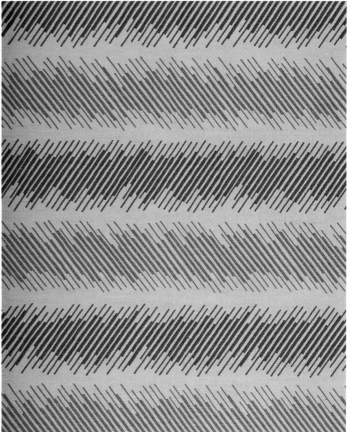

Cotton. USA. 1950s.

Cotton. USA. 1950s.

Silk. France. 1955.

Cotton. France. 1962.

Silk. France. 1959.

Cotton. France. 1962.

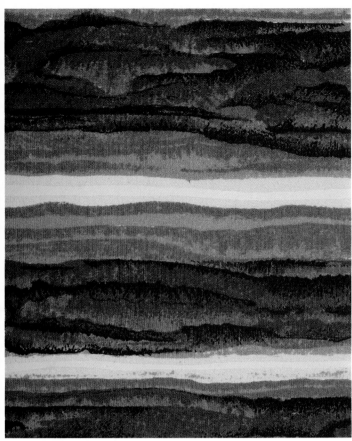

Silk. France. 1962.

Nylon. France. 1962.

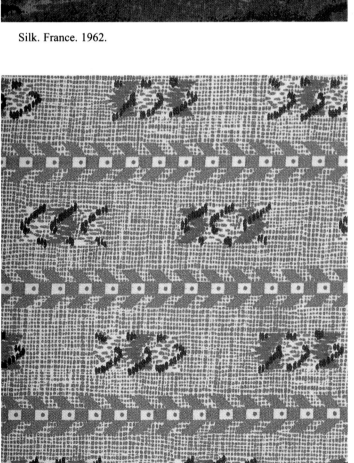

Rayon. USA. 1959.

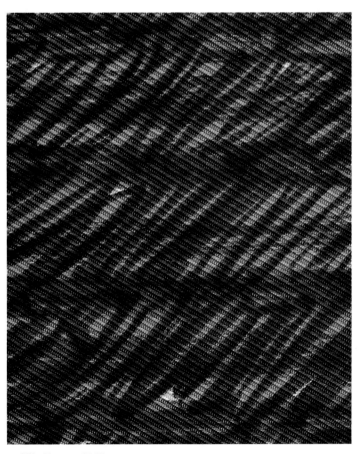

Silk. France. 1962.

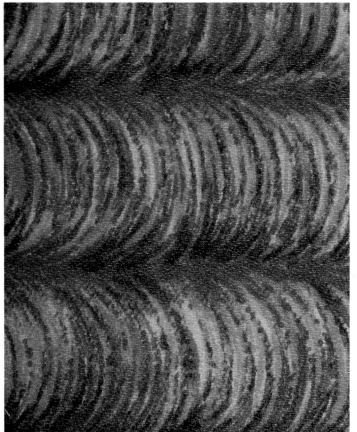

Wool. France. 1966.

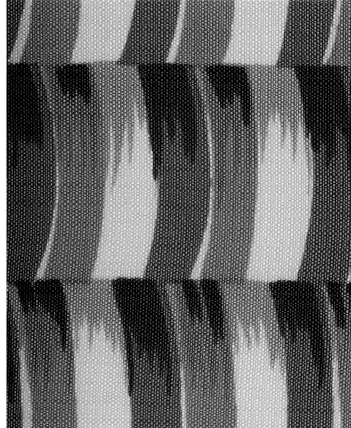

France. 1967.

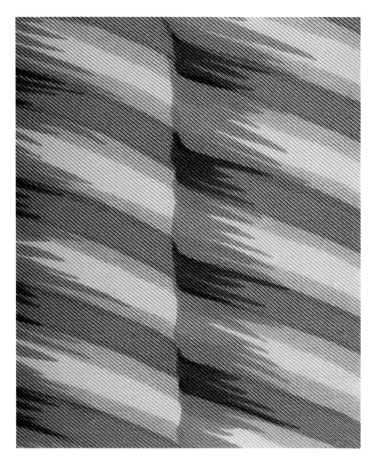

Polyester. France. 1966.

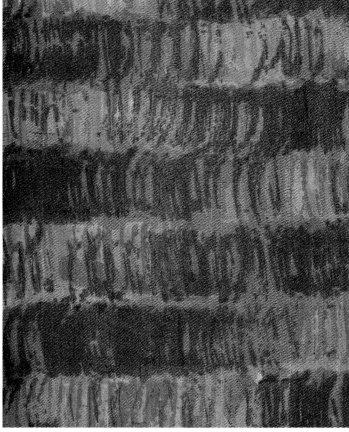

Silk. France. 1959.

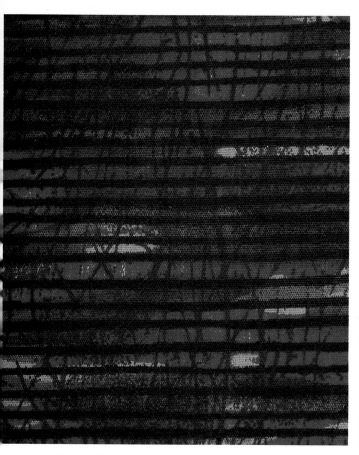

Cotton. France. 1962.

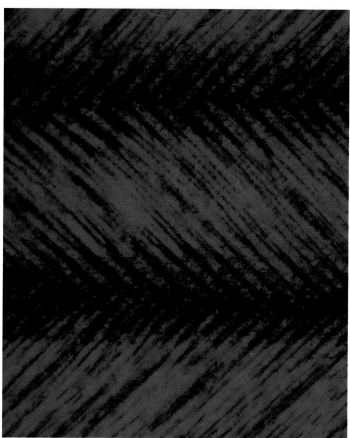

Cotton/polyester. France. 1962.

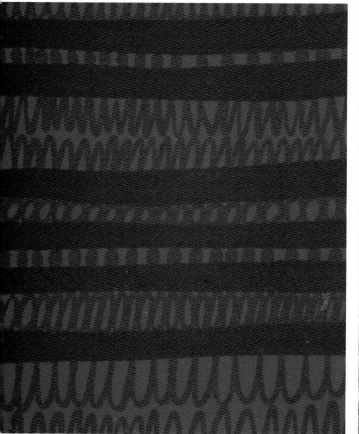

Cotton/polyester. France. 1962.

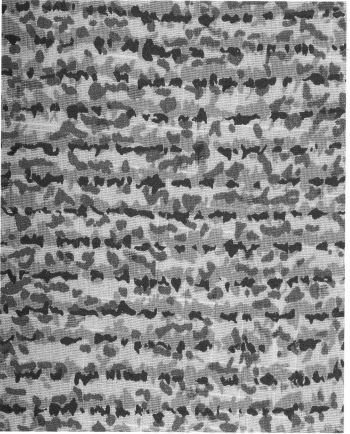

Cotton. France. 1950s.

Spun rayon/nylon. USA. 1980s. Cotton/polyester. USA. 1980s.

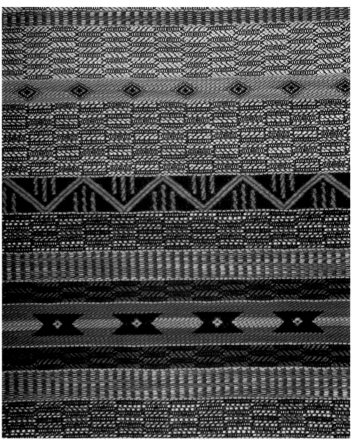

Cotton/polyester. USA. 1980s. Cotton. France. 1962.

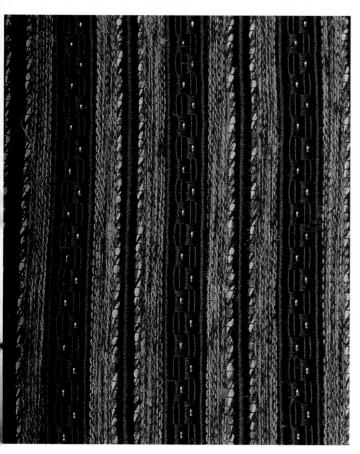

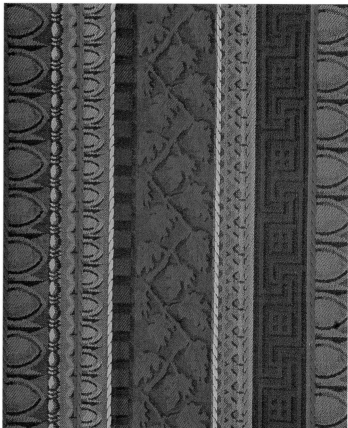

Polyester blend. USA. 1960s.

Cotton/polyester. USA. 1980s.

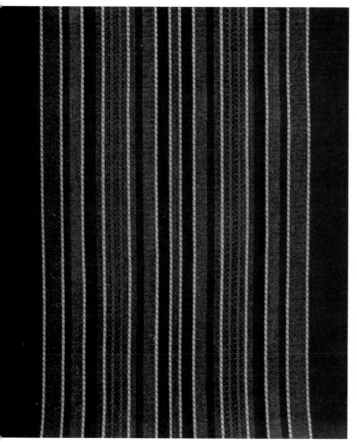

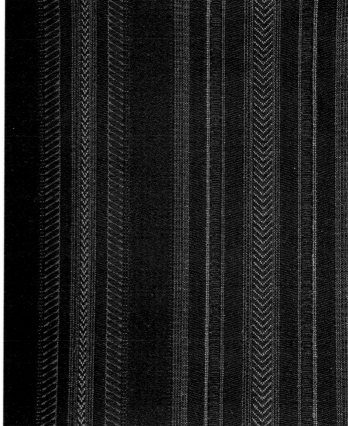

Silk. France. 1963.

Cotton. France. 1963.

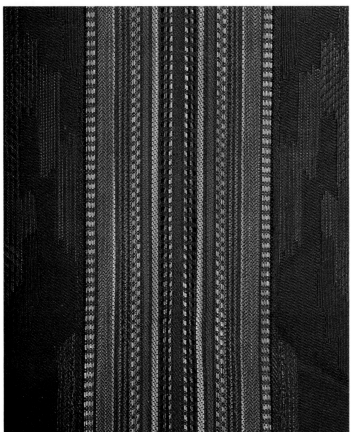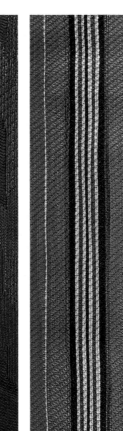

Polyester/rayon. USA. 1980s.

Spun rayon/nylon. USA. 1980s.

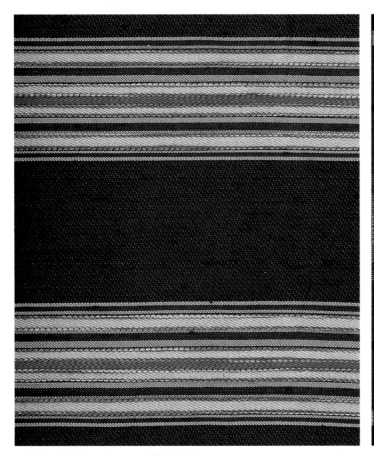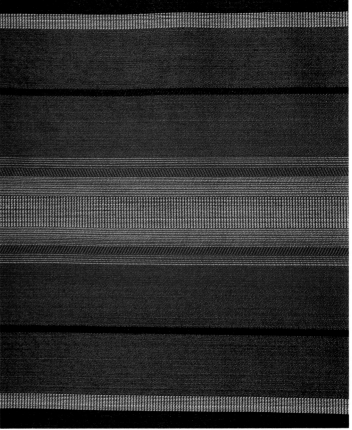

Rayon/polyester/cotton. USA. 1980s.

Rayon/polyester. USA. 1980s.

Cotton/rayon/linen. USA. 1980s.

Polyester/spun rayon/cotton/Olefin/Acrylic/nylon. USA. 1980s.

Rayon/polyester. USA. 1980s.

Olefin/polyester/rayon. USA. 1980s.

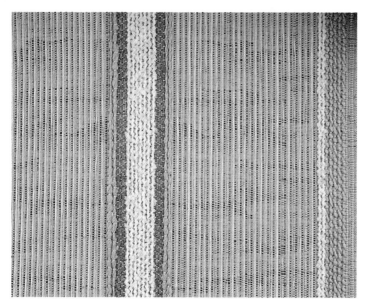
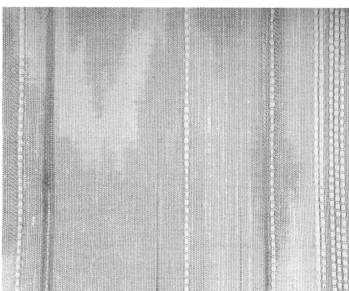

Polyester/spun rayon/cotton/Olefin/acrylic/nylon. USA. 1980s.　　Polyester/rayon. USA. 1980s.

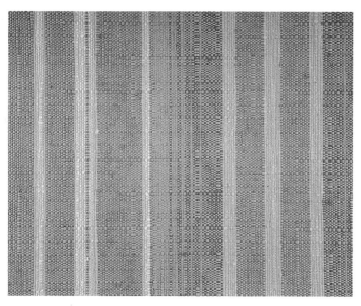
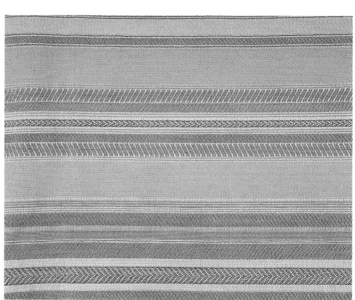

Rayon/polyester. USA. 1980s.　　　　　　　　　　Rayon/polyester. USA. 1980s.
Rayon/polyester. USA. 1980s.　　　　　　　　　　Rayon/polyester. USA. 1980s.

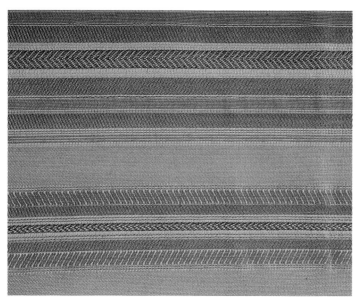
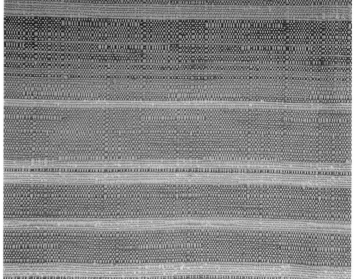

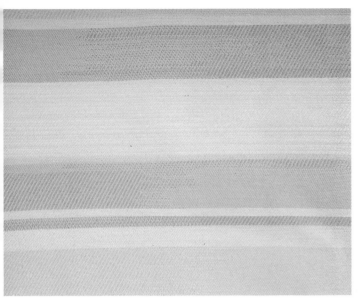

Rayon/Polyester/cotton. USA. 1980s.

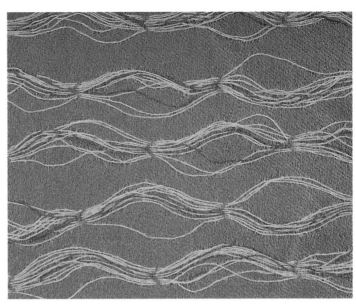

Rayon/nylon. USA. 1980s.

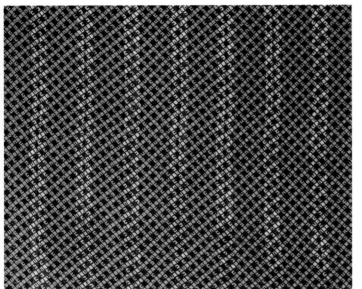

Silk. USA. 1950s.
Japan. Metallic. 1950s.

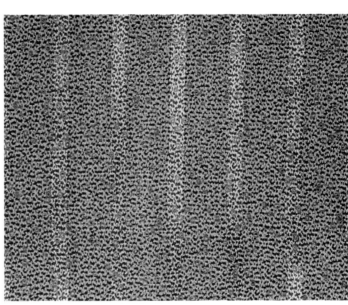

Silk. USA. 1950s.
Japan. Metallic. 1950s.

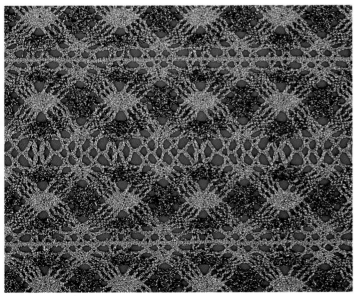

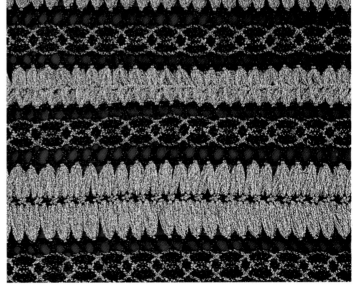

Silk. France. 1962.

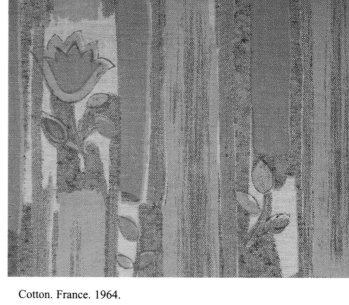

Cotton. France. 1964.

Polyester/cotton. France. 1962.
Cotton. France. 1963.

Silk/polyester. France. 1963.
Cotton/acetate. France.

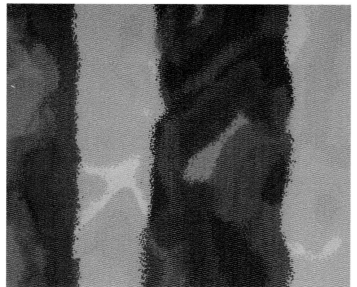

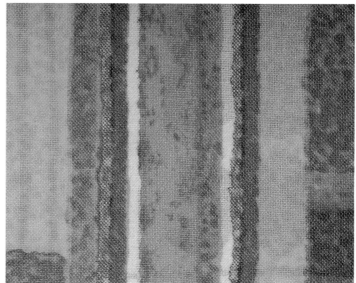

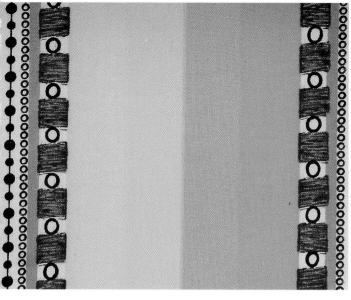

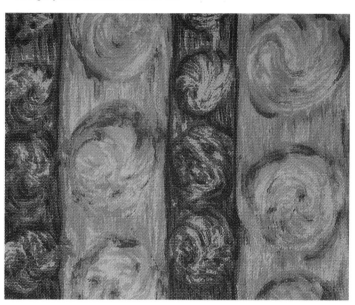

Cotton. France. 1962.

Silk/polyester blend. France. 1966.

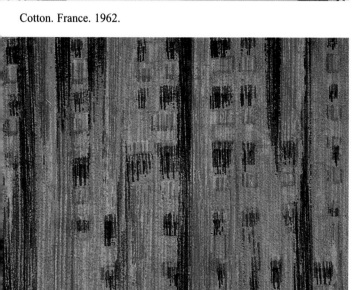

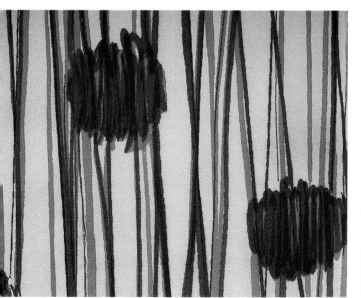

Cotton. France. 1962.

Silk. France 1950s.

Cotton. France. 1962.

Cotton. France. 1964.

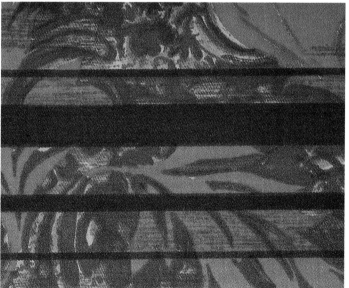

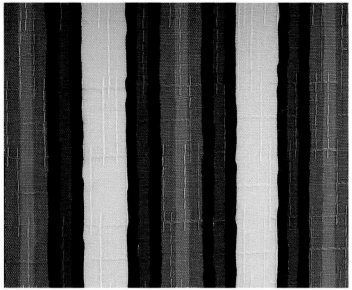

Cotton/acetate. France. 1966.

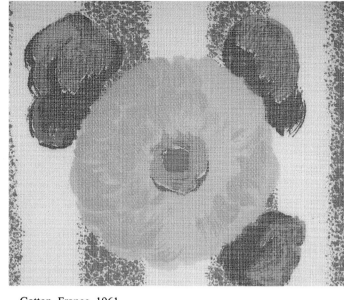

Cotton. France. 1961.

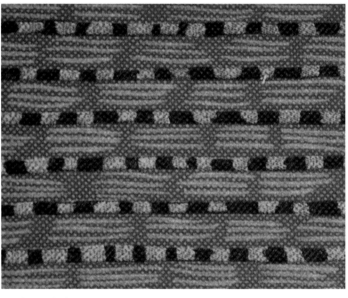

Cotton/polyester. France. 1964.
Cotton. France. 1964.

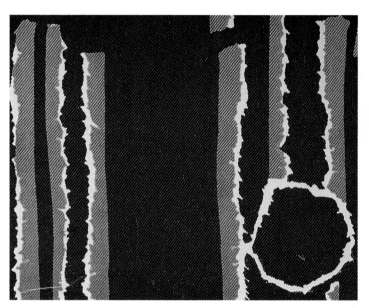

Polyester. France 1966.
Rayon. France. 1962.

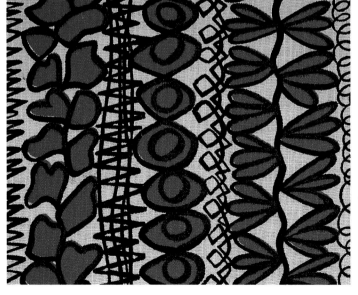

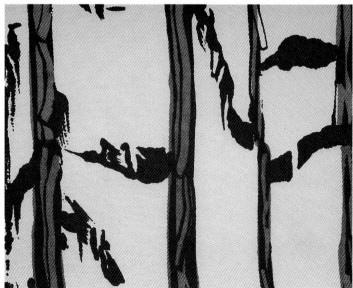

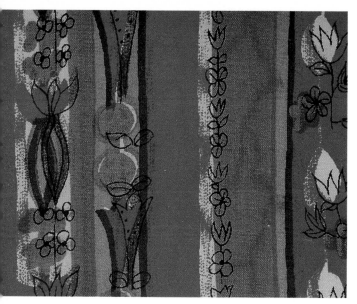

Cotton. France. 1963.

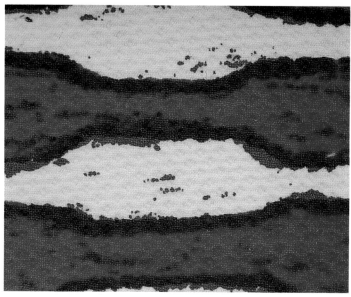

Cotton. France. 1962.

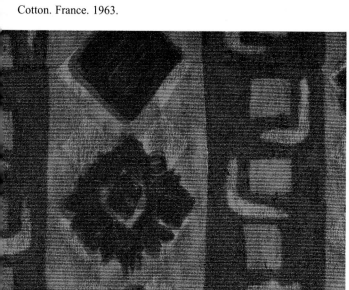

Cotton/rayon. France. 1959.
Cotton/rayon. France. 1964.

Cotton. France. 1950s.
Cotton. France. 1959.

Cotton. France. 1964.

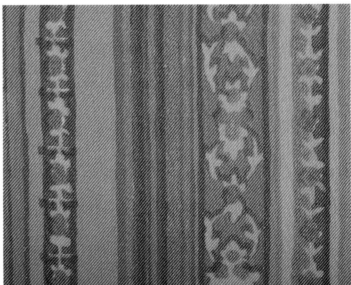

Silk. France. 1966.

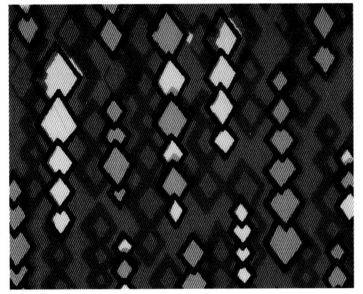

Rayon/cotton blend twill. France. 1966.
Cotton. France. 1962.

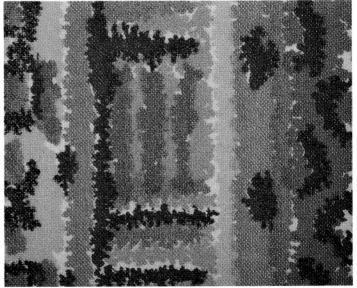

Silk. France. 1966.
Nylon/cotton. France. 1962.

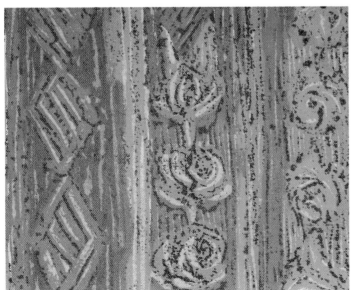

Polished cotton. France. 1963.

Silk. France. 1962.

Cotton. USA. 1965.
Cotton. USA. 1965.

Cotton. USA. 1965.
Cotton. USA. 1965.

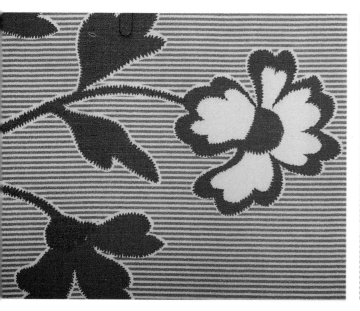

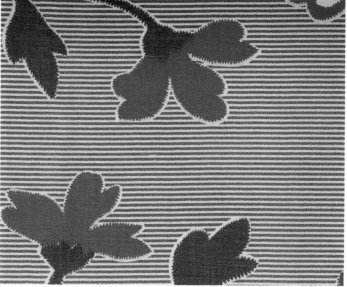

Cotton. USA. 1965.

Cotton. USA. 1965.

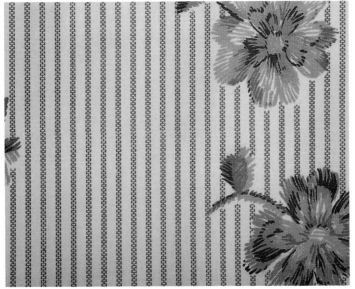

Cotton. USA. 1965.
Cotton. USA. 1965.

Cotton. USA. 1965.
Cotton. USA. 1965.

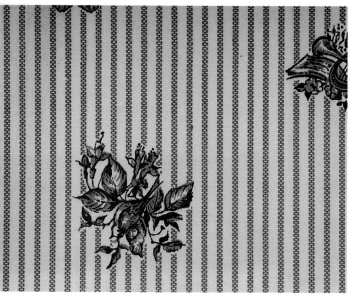

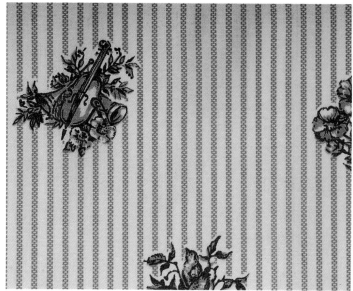

Cotton. USA. 1965.

Cotton. USA. 1965.

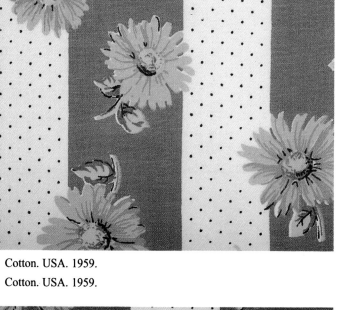

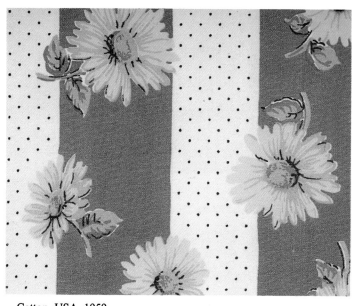

Cotton. USA. 1959.

Cotton. USA. 1959.

Cotton. USA. 1959.

Cotton. USA. 1959.

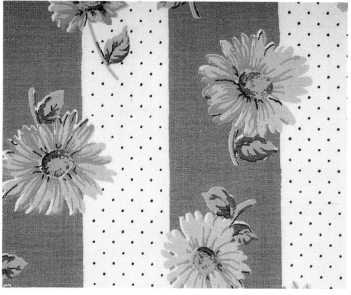

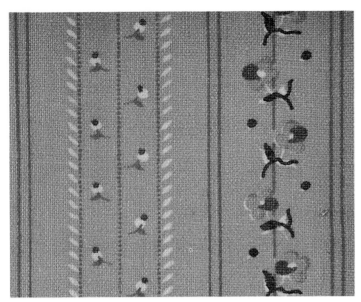

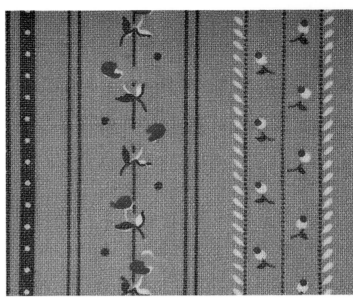

Cotton. USA. 1940s.

Cotton. USA. 1940s.

Cotton. USA. 1940s.

Cotton. USA. 1940s.

Cotton. USA. 1940s.

Cotton. USA. 1940s.

Cotton. USA. 1940s. Cotton. USA. 1940s.

Cotton. USA. 1940s. Cotton. USA. 1940s.
Cotton. USA. 1940s. Cotton. USA. 1940s.

Cotton. USA. 1940s.

Cotton. USA. 1940s.

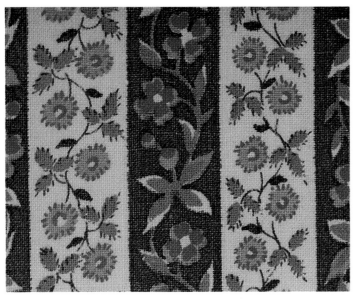

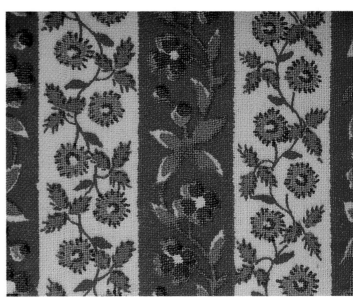

Cotton. USA. 1940s.
Cotton. USA. 1948.

Cotton. USA. 1940s.
Cotton. USA. 1948.

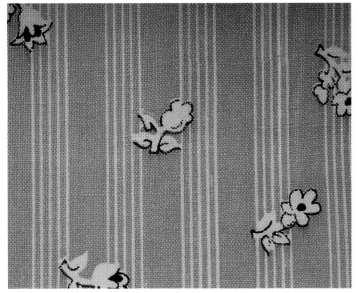

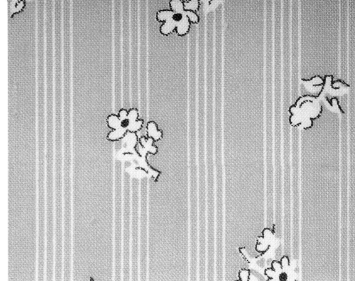

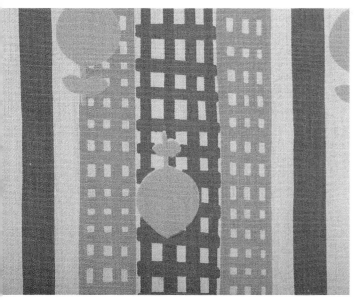 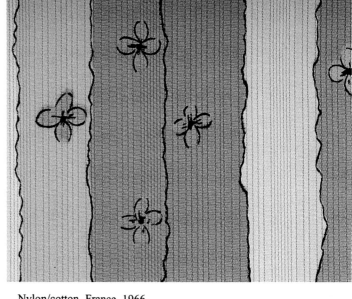

Cotton. France. 1963. Nylon/cotton. France. 1966.

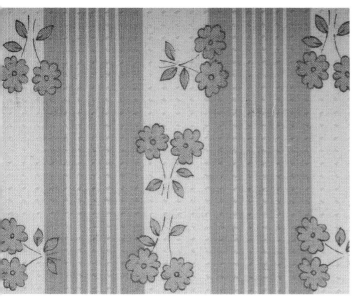 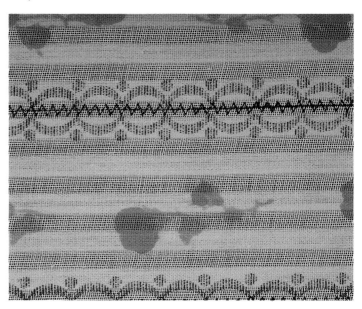

Cotton. France. 1966. Cotton. France. 1966.
Cotton. USA. 1965. Cotton. USA. 1965.

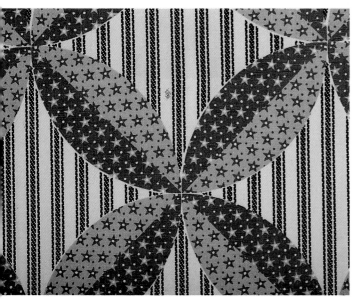 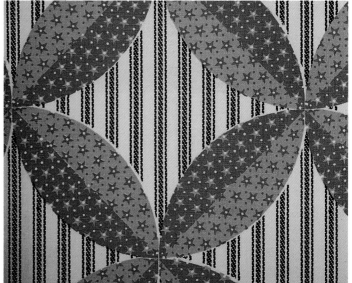

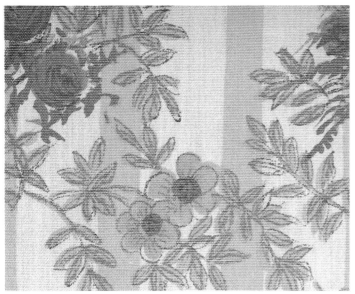

Cotton. France. 1964.

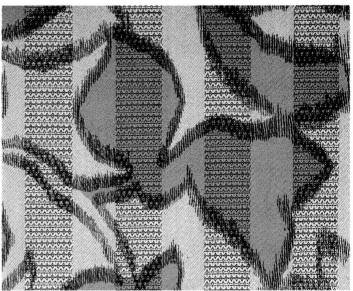

Cotton. France. 1963.

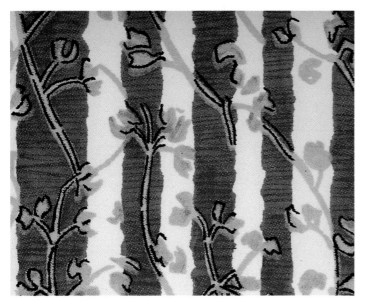

Cotton/polyester. France. 1962.
Cotton. USA. 1963.

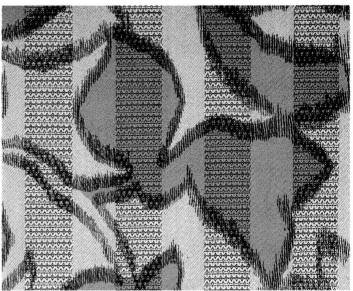

Cotton/polyester. France. 1964.
Cotton. USA. 1963.

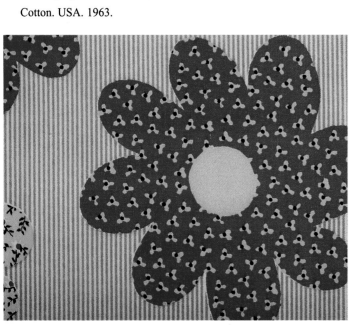

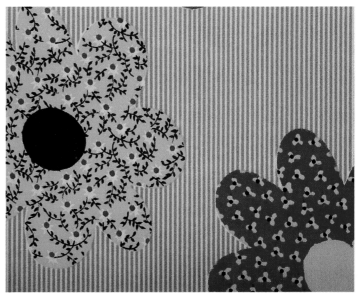

Cotton. USA. 1963.

Cotton. USA. 1963.

Cotton/rayon. USA. 1963.

Cotton/rayon. USA. 1963.

Cotton/rayon. USA. 1963.

Cotton/rayon. USA. 1963.

Cotton. USA. 1948. Cotton. USA. 1948.

Cotton. USA. 1970. Cottons. USA. 1970.

Cotton. Italy. 1950s. Cotton. Italy. 1950s.

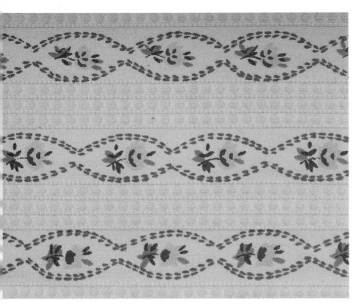

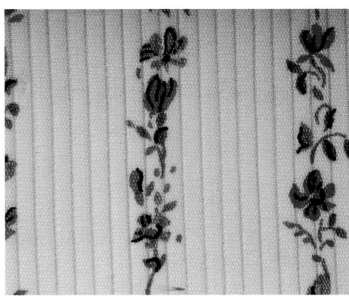

Cotton/rayon. France. 1950s.

Cotton/polyester. France. 1955.

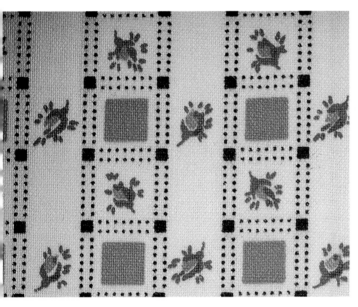

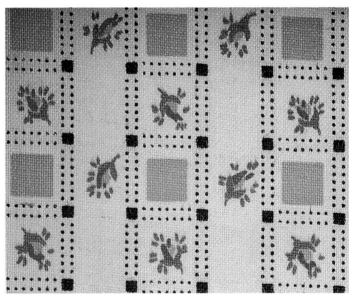

Cotton. USA. 1950s.
Cotton. USA. 1950s.

Cotton. USA. 1950s.
Cotton. USA. 1950s.

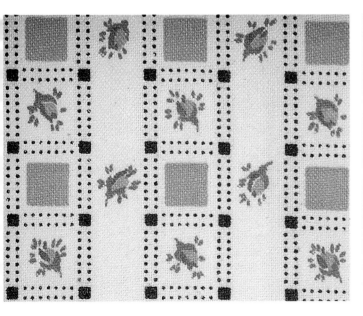

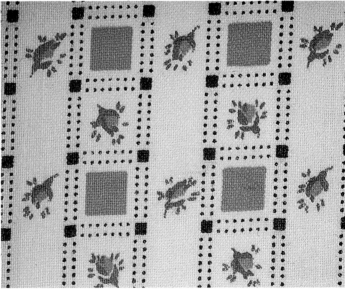

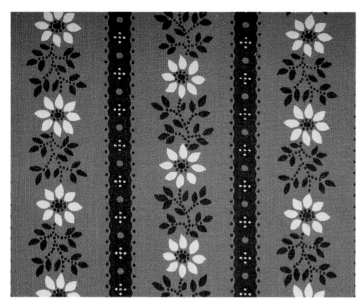

Cotton. USA. 1959.

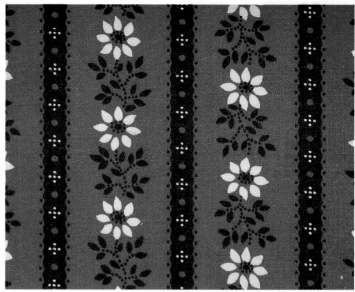

Cotton. USA. 1959.

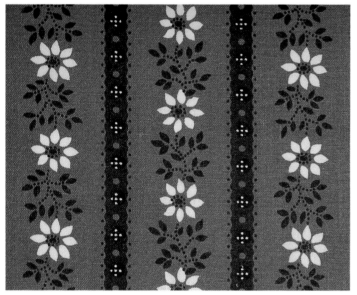

Cotton. USA. 1959.
Cotton. USA. 1950s.

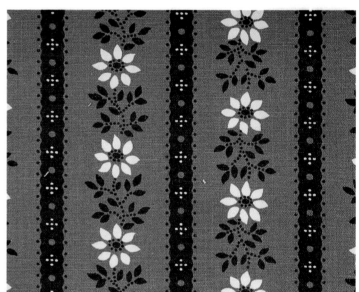

Cotton. USA. 1959.
Cotton. USA. 1950s.

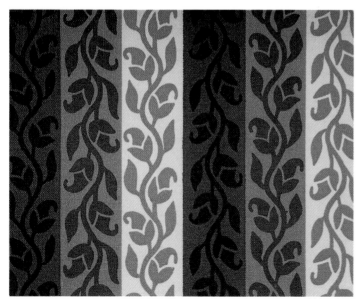

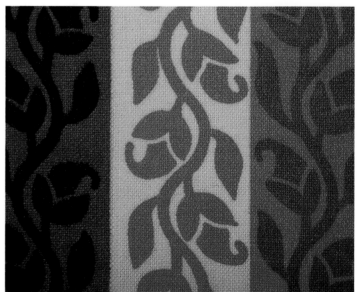

Cotton. USA. 1950s. Cotton. USA. 1950s.

Silk. France. 1962. Polyester/cotton. France. 1964.
Cotton. Italy. 1963. Cotton. USA. 1950s.

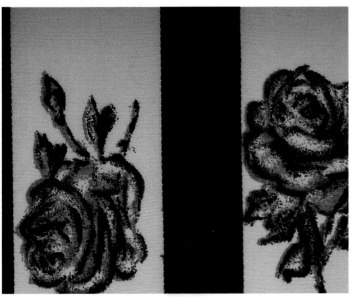 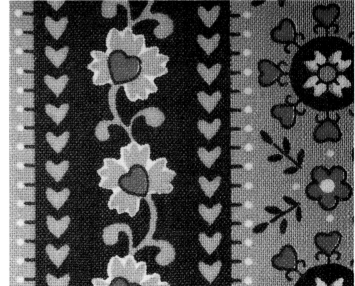

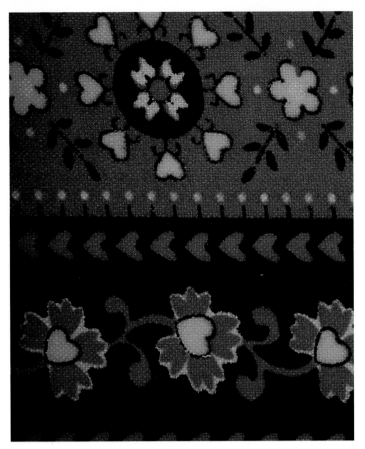

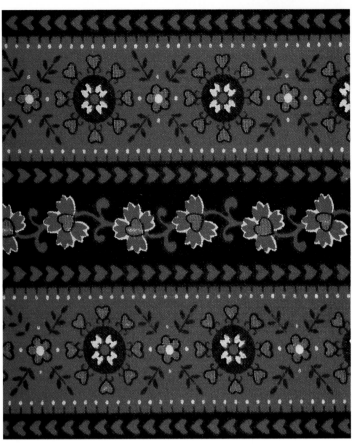

Cotton. USA. 1950s.

Cotton. USA. 1950s.

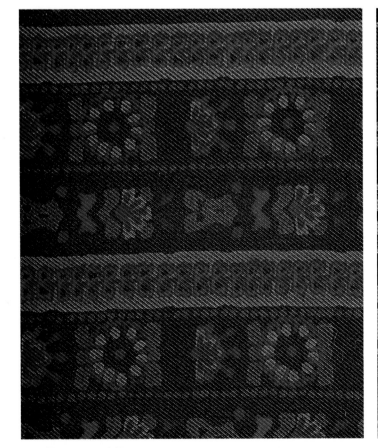

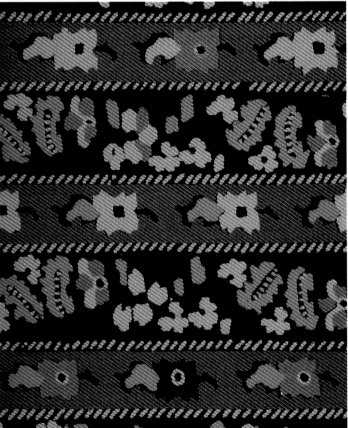

Silk. France. 1967.

Silk. France. 1967.

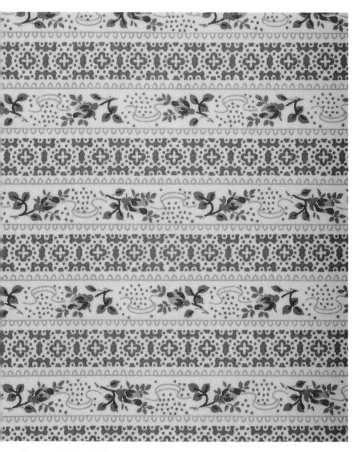

Cotton. USA. 1963.

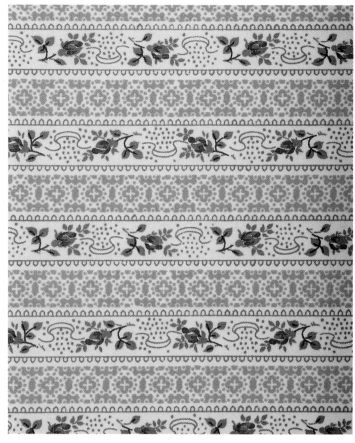

Cotton. USA. 1963.

Cotton. USA. 1963.

Cotton. USA. 1963.

Cotton. France. 1964.

Cotton. France. 1961.

Cotton/polyester. France. 1962.

Cotton. France. 1964.

Cotton. France. 1963.

Cotton. France. 1963.

Cotton. France. 1966.

Cotton/rayon. France. 1964.

Cotton. France. 1966.

Cotton/polyester. France. 1966.

Cotton. France. 1966.

Cotton blend. France. 1966.

Nylon. France. 1950s.

Cotton/polyester. France. 1950s.

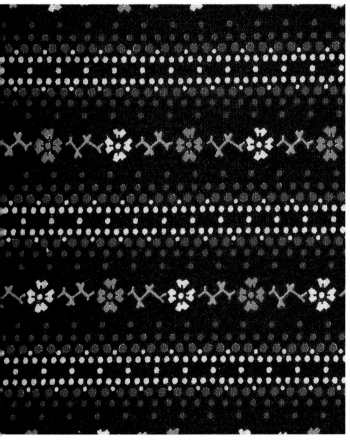

Rayon/cotton. USA. 1959.

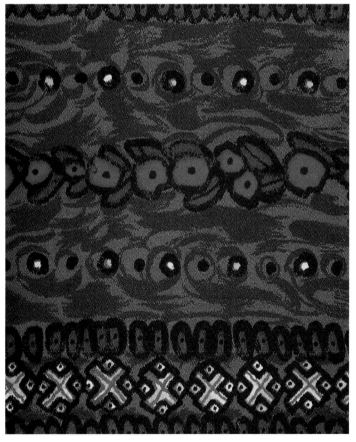

Cotton blend. France. 1963.

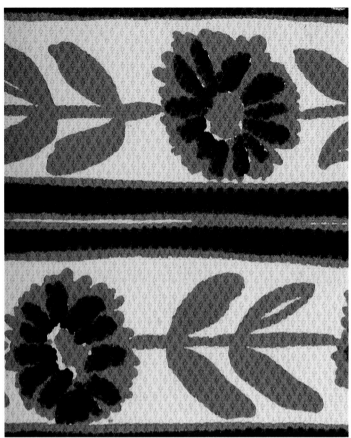

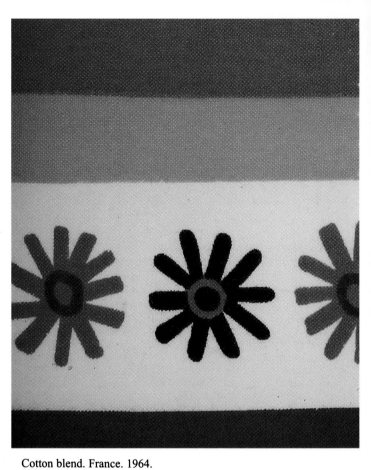

Cotton/polyester. France. 1963.

Cotton blend. France. 1964.

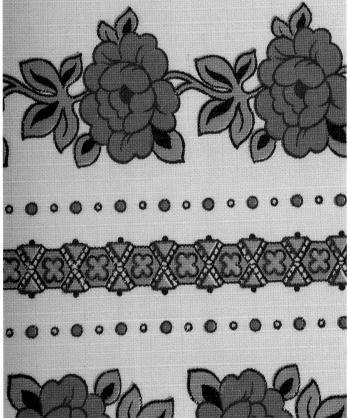

Nylon. France. 1966.

Cotton. France. 1966.

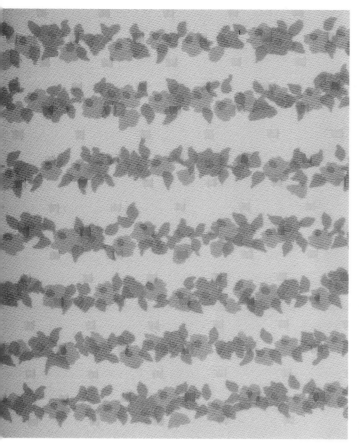

Cotton. France. 1966.

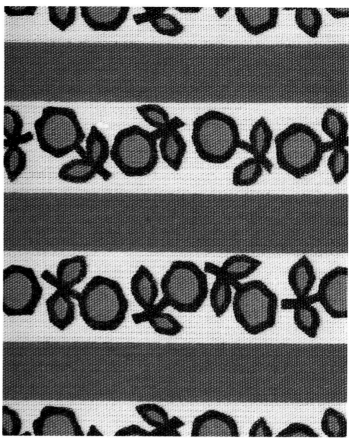

Cotton. France. 1964.

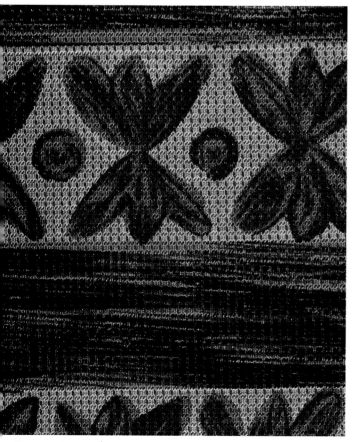

France. 1959.

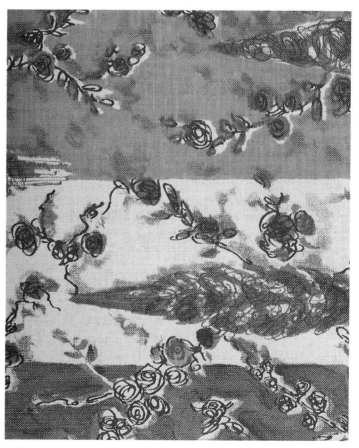

Cotton. France. 1963.

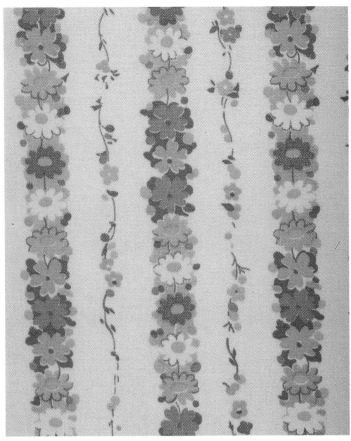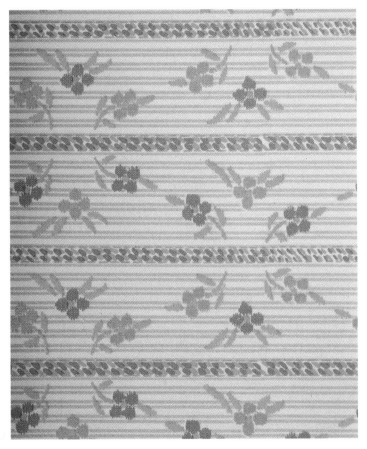

Cotton. USA. 1969.

Cotton blend. France. 1960.

Cotton. USA. 1970.

Cotton. USA. 1970.

Cotton. France. 1963.

Linen blend. France. 1966.

Cotton. France. 1962.

Cotton. France. 1964.

Cotton. USA. 1948.

Cotton. USA. 1950s.

Cotton. France. 1966.

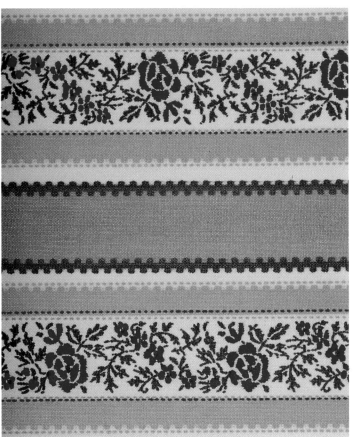

Cotton. USA. 1950s.

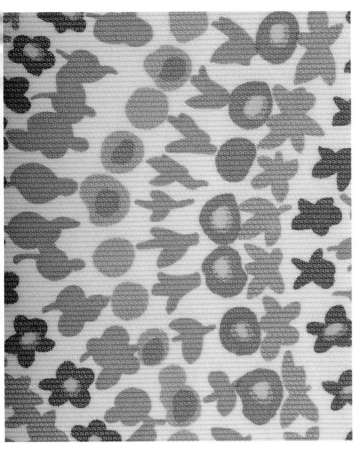

Cotton/rayon. France. 1966.

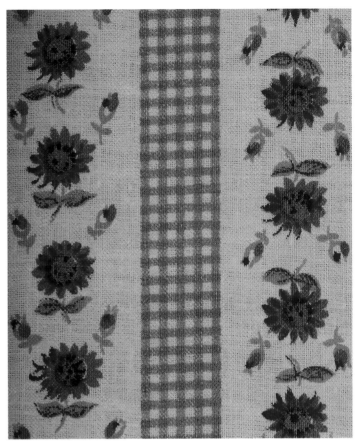

Cotton. France. 1966.

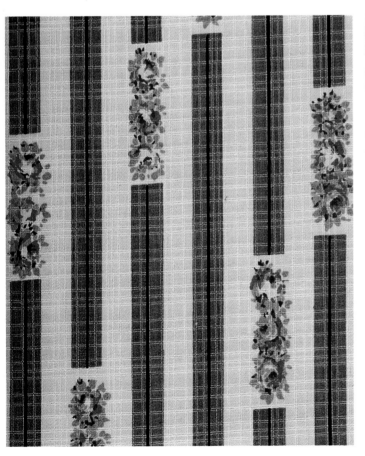

Cotton. France. 1950s.

Cotton. France. 1966.

Cotton. USA. 1970.

Cotton/rayon. France. 1966.

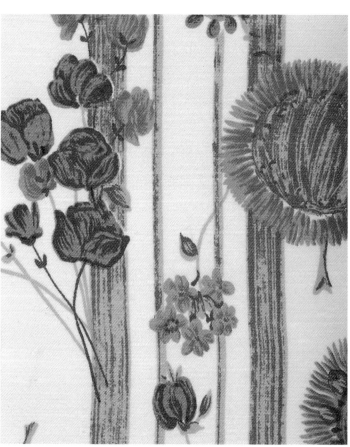

Cotton. France. 1966.

Cotton/rayon. France. 1962.

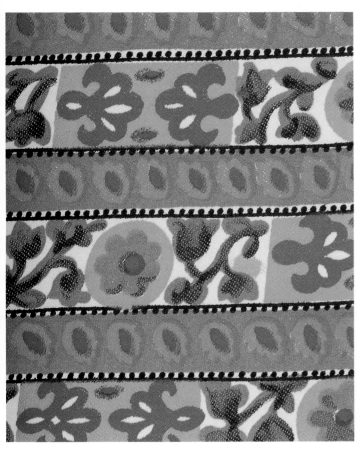

Cotton/rayon. France. 1963.

Cotton. France. 1963.

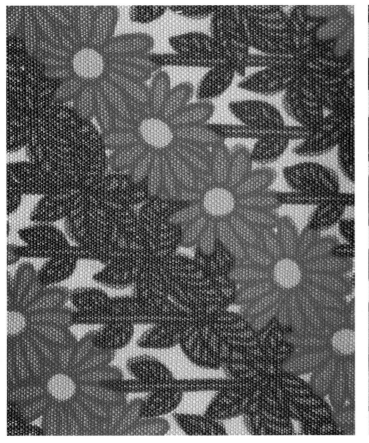

Cotton. France. 1962.

Cotton. France. 1963.

Cotton. France. 1966.

Cotton. USA. 1950s.

Cotton. France. 1964.

Silk. France. 1961.

76

Cotton/polyester. France. 1963.

France. 1964.

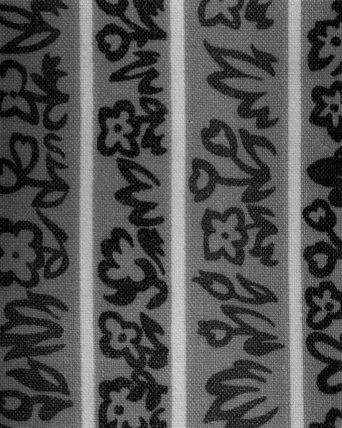

Cotton. USA. 1948.

Cotton. USA. 1948.

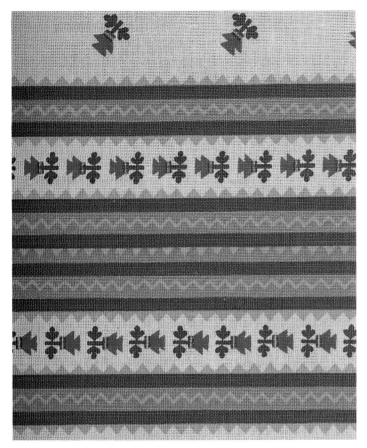
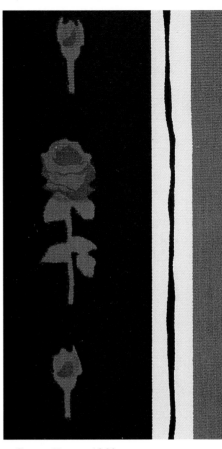

Cotton. France. 1964.

Cotton. France. 1966.

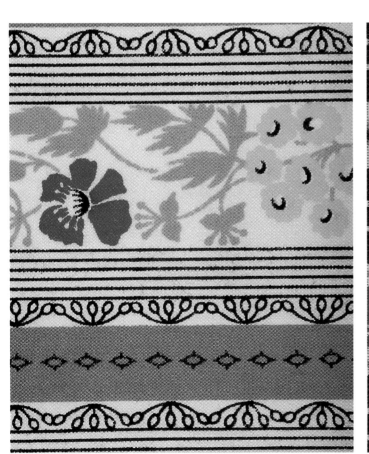
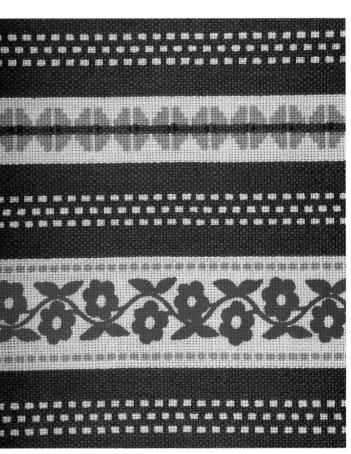

Cotton. France. 1955.

Cotton. France. 1966.

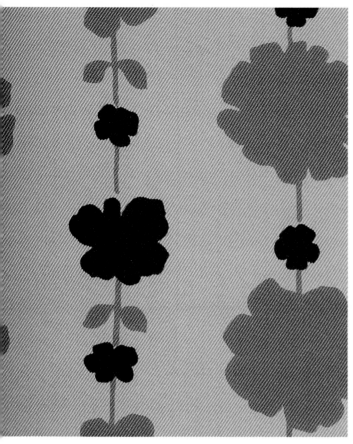

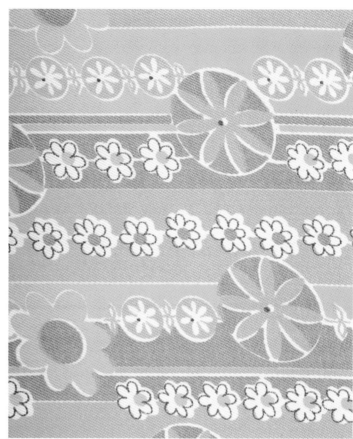

Silk. France. 1963.

Cotton/rayon. France. 1963.

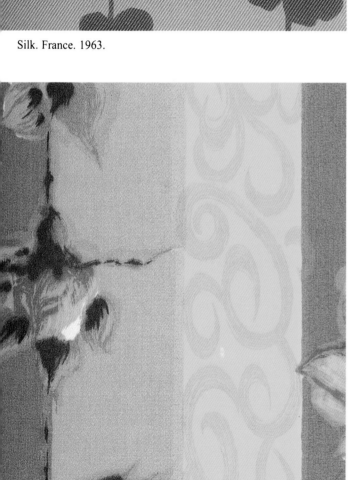

Cotton. France. 1963.

Cotton. France. 1963.

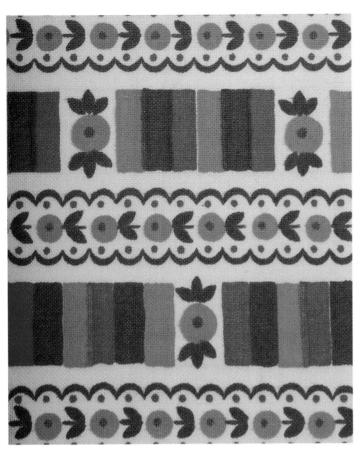

Cotton. France. 1966.

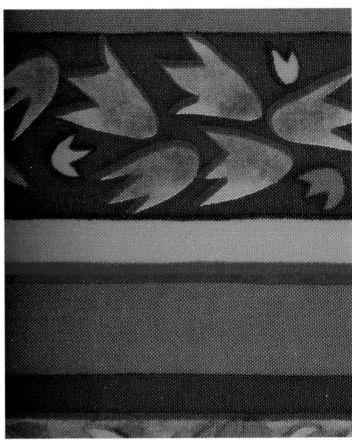

Silk. France. 1966.

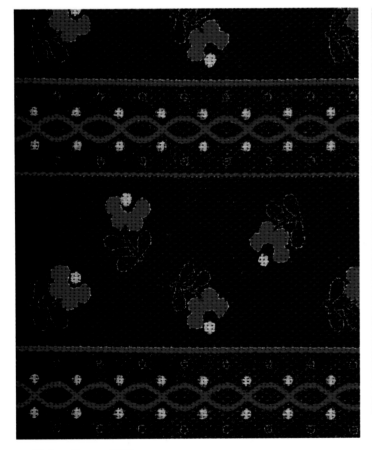

Cotton. France. 1966.

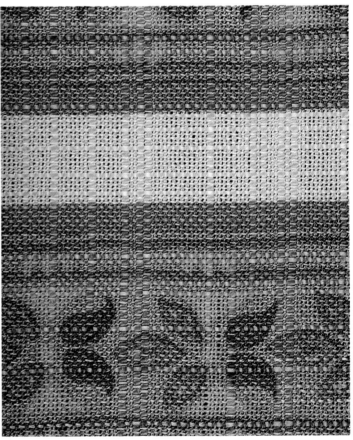

Acetate. France. 1966.

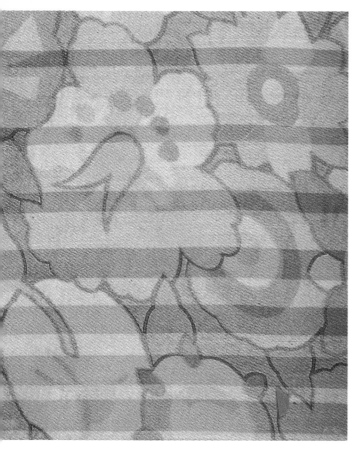

Silk. France. 1920s.

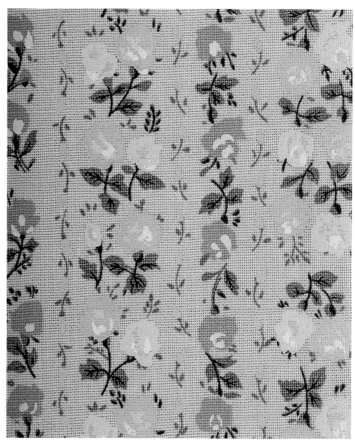

Cotton/polyester. France. 1950s.

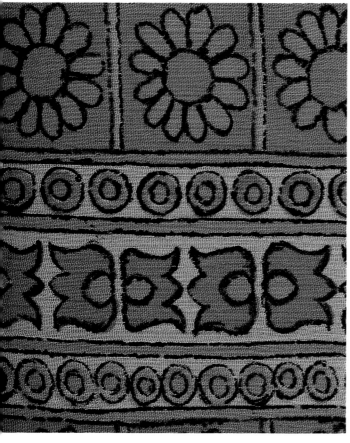

Cotton/polyester. France. 1964.

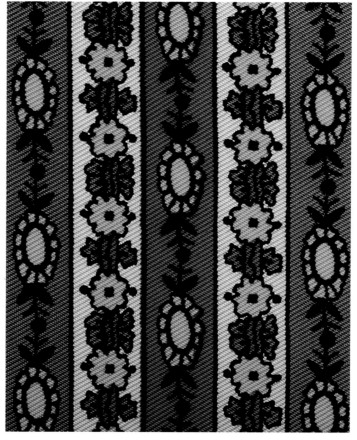

Silk. France. 1964.

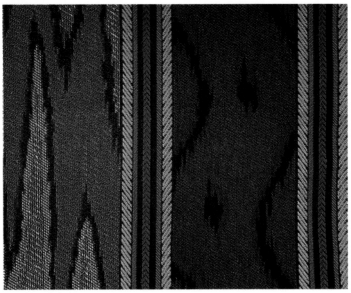

Rayon/polyester. USA. 1980s.

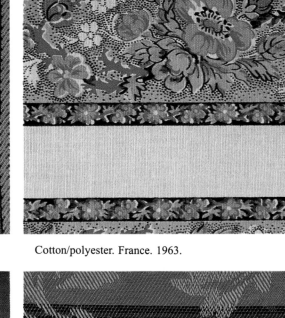

Cotton/polyester. France. 1963.

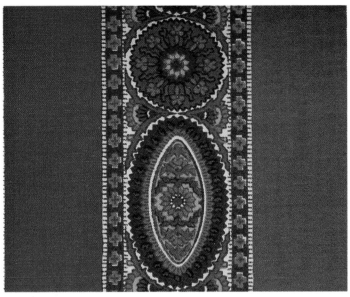

Cotton. France. 1964.
Rayon/polyester. USA. 1980s.

Cotton/polyester. USA. 1980s.
Rayon/polyester. USA. 1980s.

Cotton/polyester. USA. 1980s.

Polyester/cotton. USA. 1980s.

Rayon/nylon. USA. 1980s.
Cotton/polyester. USA. 1980s.

Polyester/cotton/rayon. USA. 1980s.
Cotton. USA. 1980s.

Nylon. France. 1966.

Cotton/polyester. France. 1966.

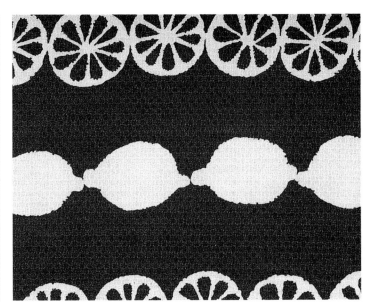

Cotton/rayon blend. France. 1955.
Cotton. France. 1962.

Cotton. France. 1950s.
Cotton. USA. 1950s.

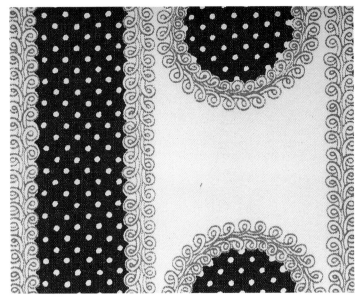

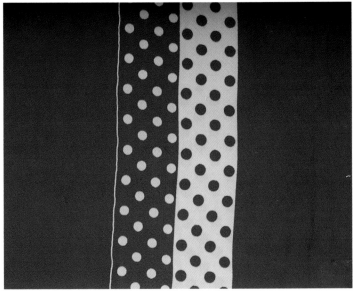

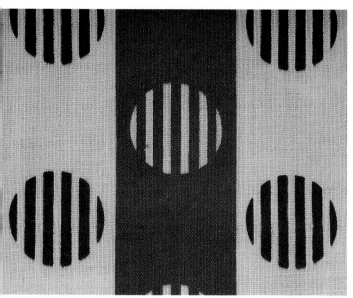

Cotton. France. 1920s.

Silk. France. 1961.

Polyester/cotton. France. 1950s.
Cotton/polyester blend. France. 1955.

Cotton/rayon. France. 1950s.
Silk. France. 1950s.

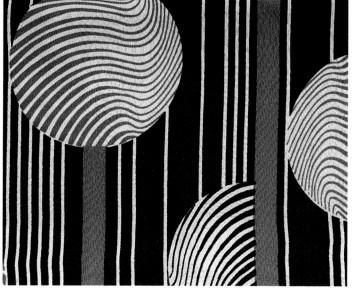

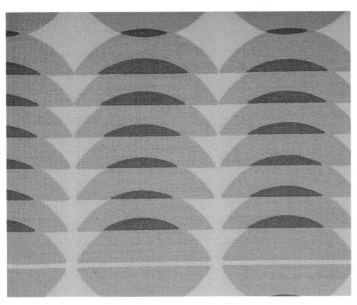

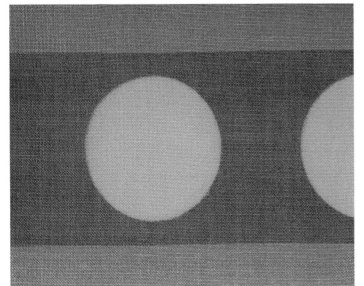

Cotton. France. 1963.

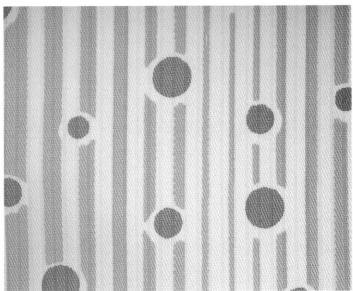

Cotton. France. 1963.

Cotton. France. 1963.
Cotton. USA. 1935.

Cotton. France. 1963.
Cotton. USA. 1935.

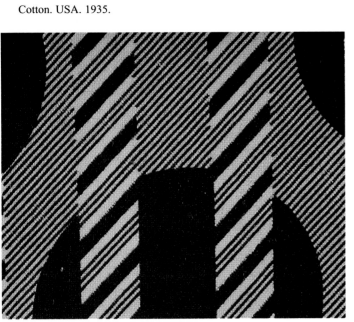

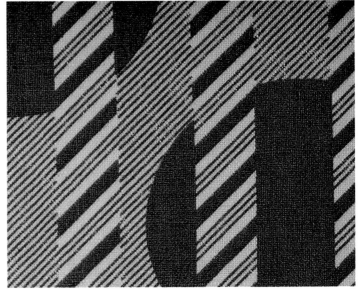

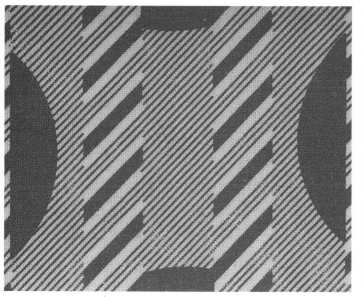

Cotton. USA. 1935.

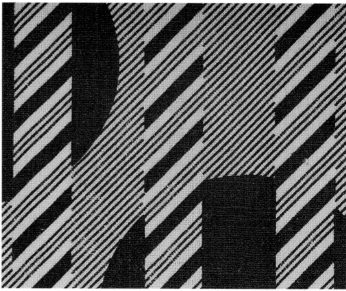

Cotton. USA. 1935.

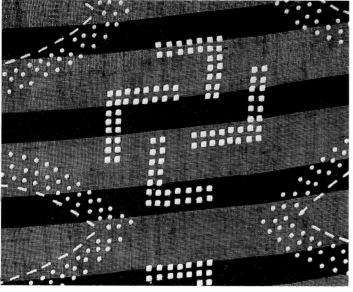

France. 1920s.
Cotton. France. 1920s.

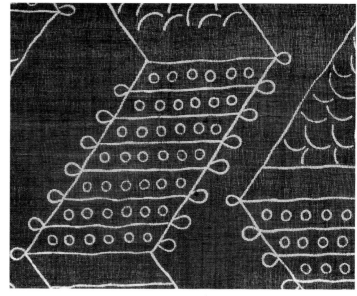

France. 1920s.
Cotton. France. 1920s.

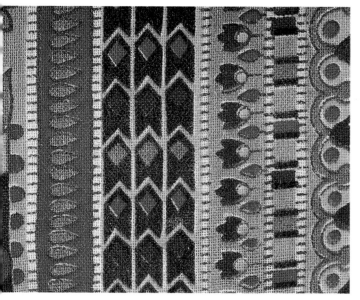

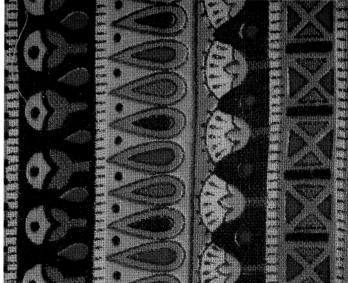

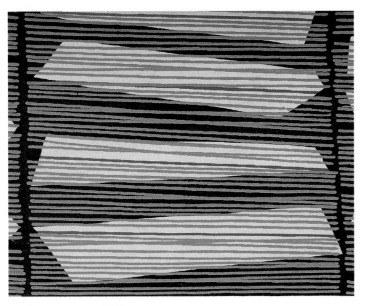

Cotton. France. 1950s.

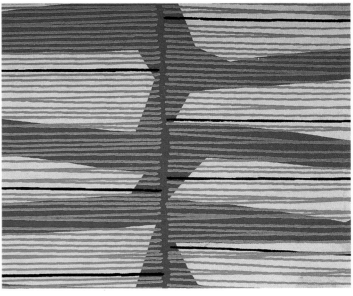

Cotton. France. 1950s.

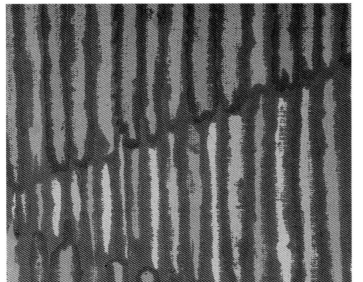

Silk. France. 1964.
Cotton. France. 1962.

Wool. France. 1966.
Cotton/polyester. France. 1966.

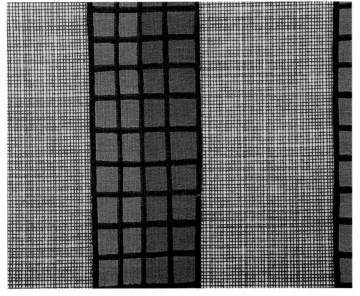

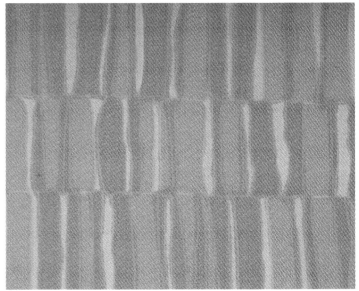

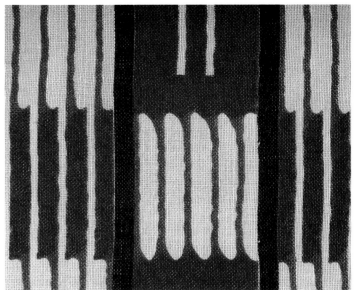

Wool. France. 1966.

Cotton. France. 1920s.

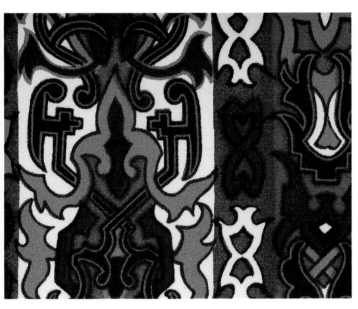

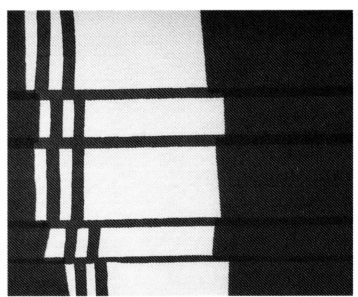

Cotton/polyester. France. 1963.
Cotton. USA. 1950s.

Polyester. France 1966.
Cotton/polyester. USA. 1980s.

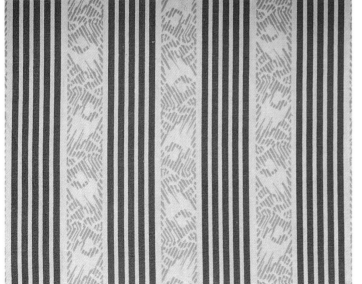

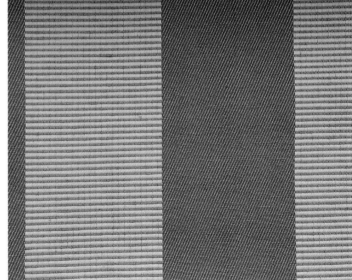

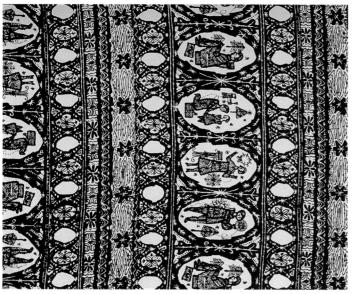

Cotton. France. 1950s.

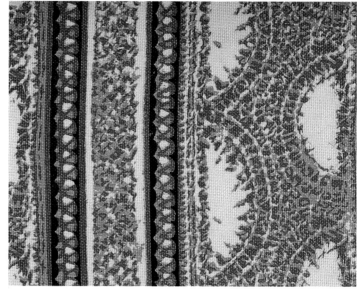

Cotton. France. 1950s.

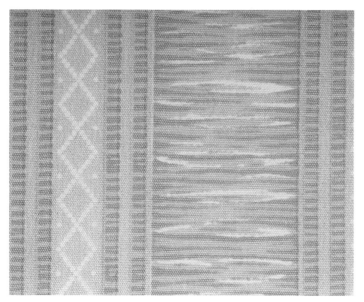

Cotton. France. 1962.
Cotton. France. 1962.

Cotton. France. 1964.
Cotton/acrylic. France. 1962

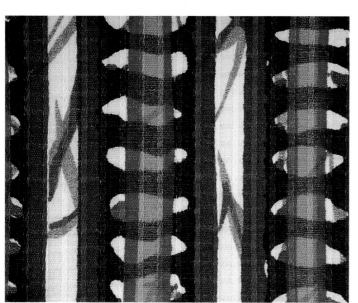

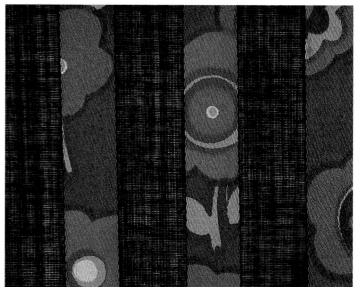

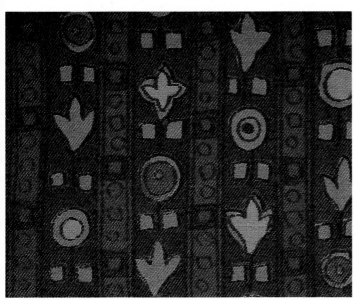

Polyester. France. 1959.

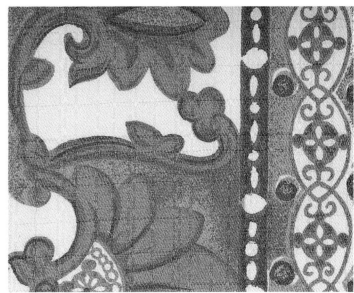

Silk/polyester. France. 1959.

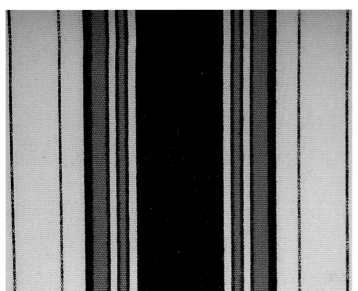

Cotton. France. 1964.
Silk. France. 1963.

Polyester. France. 1963.
Cotton/polyester. France. 1950s.

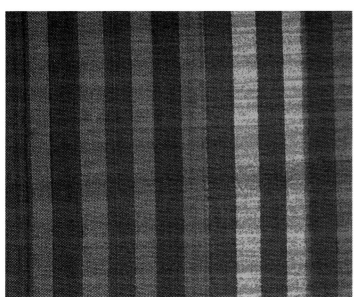

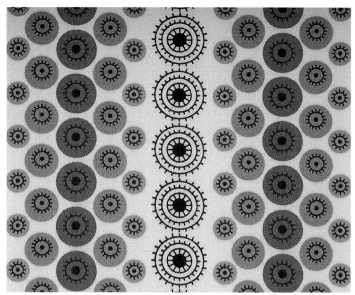

Cotton. USA. 1950s.

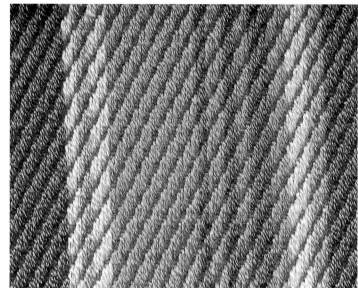

Polyester blend. USA. 1960s.

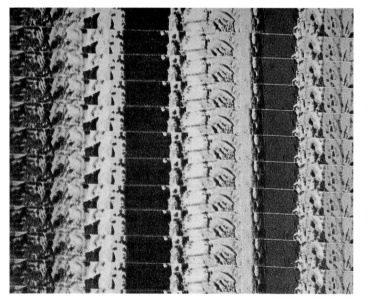

Silk/polyester. France. 1963.

Linen/rayon. France. 1966.

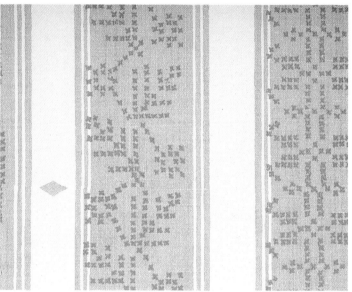

Cotton. France. 1963.

Polyester. France. 1963.

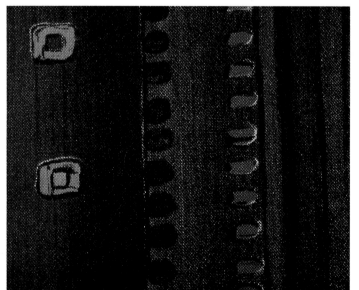

Cotton blend. France. 1966.

Cotton. France. 1962.

Cotton. France. 1966.
Silk. France. 1962.

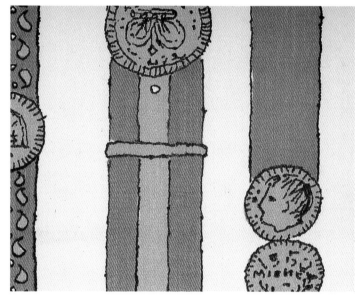

Cotton. France. 1962.
Cotton blend. France. 1966.

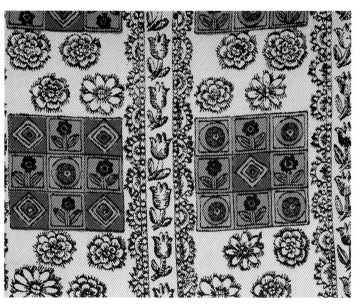

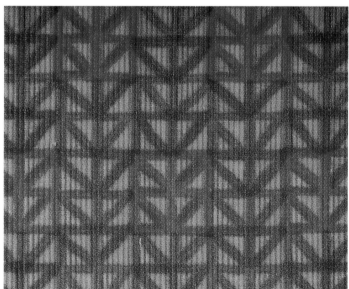

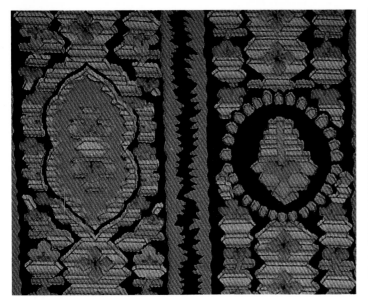

Silk/polyester. France. 1963.

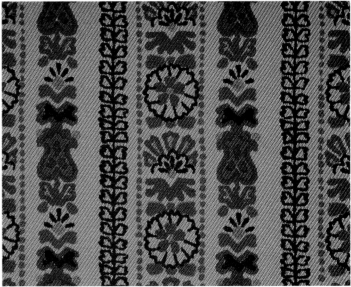

Silk. France. 1967.

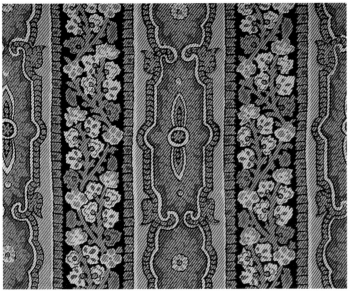

Polyester. France. 1966.

Silk. USA. 1950s.

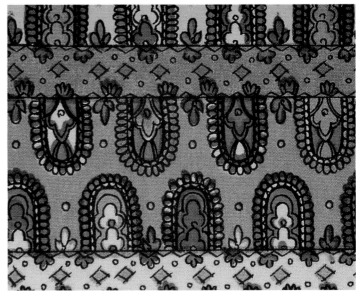

Cotton/polyester. France. 1962.

Cotton. Italy. 1963.

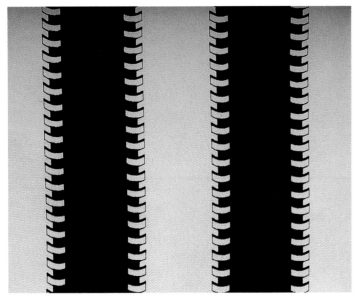

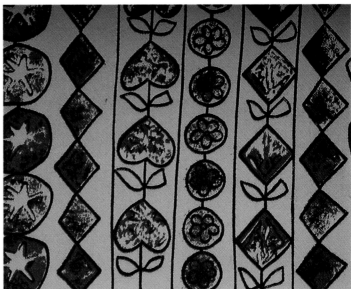

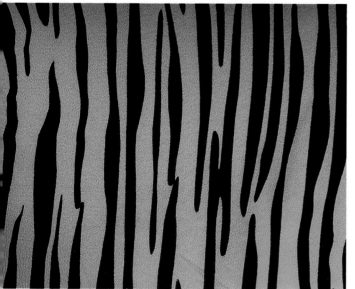

Silk. USA. 1950s.

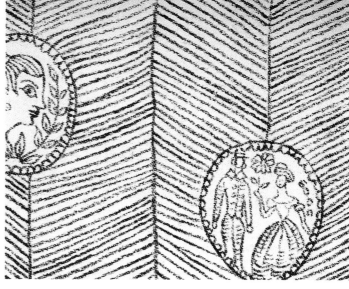

Cotton. France. 1963.

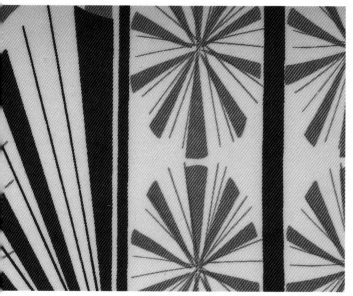

Silk. Italy. 1960s.
Cotton. France. 1950s.

Silk. Italy. 1960s.
Silk. France. 1967.

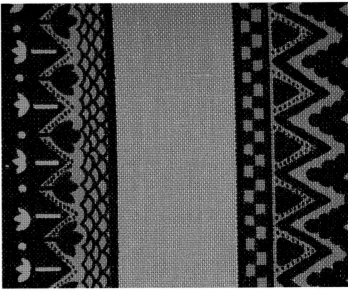

Cotton. France. 1964.

Cotton/polyester. France. 1966.

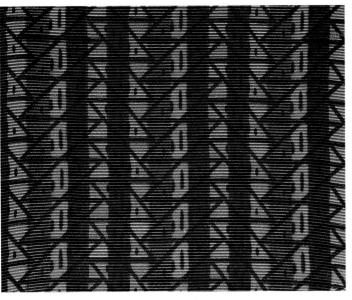

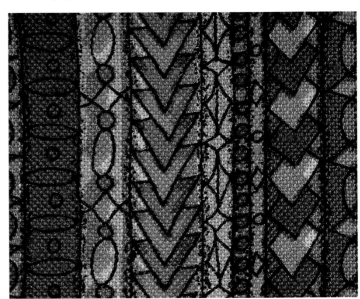

Silk/polyester blend. USA. 1960s.
Cotton/polyester. France. 1964.

Cotton. France. 1966.
Cotton. France. 1964.

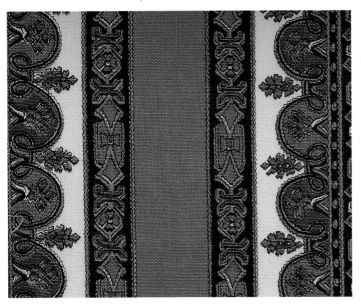

Nylon/cotton. France. 1964.

Nylon/cotton. France. 1964.

Cotton. France. 1963.
Cotton/polyester. France. 1963.

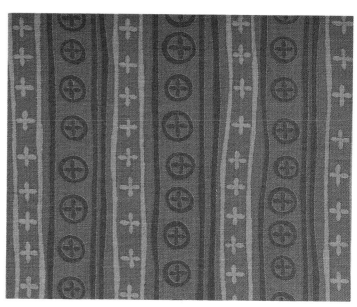

Cotton/rayon. France. 1963.
Cotton. France. 1963.

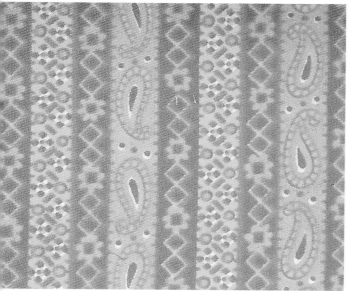

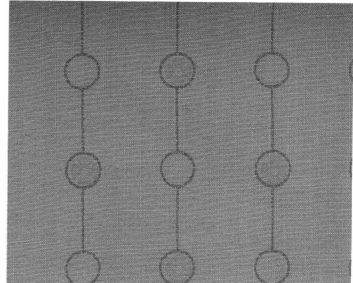

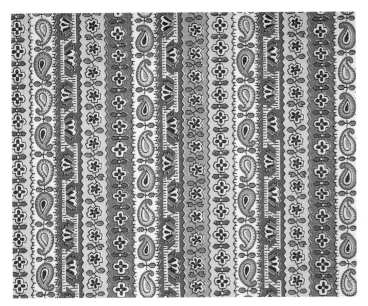

Cotton. USA. 1959.

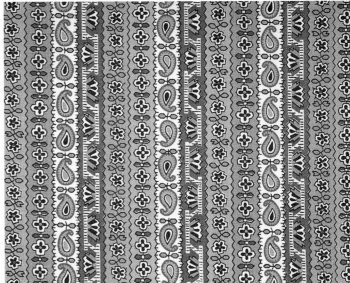

Cotton. USA. 1959.

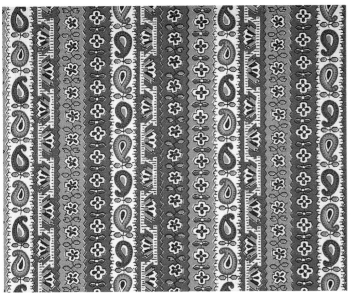

Cotton. USA. 1959.

Silk. France. 1967.

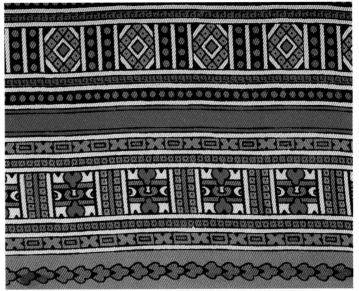

Cotton. USA. 1959.

Silk. France. 1967.

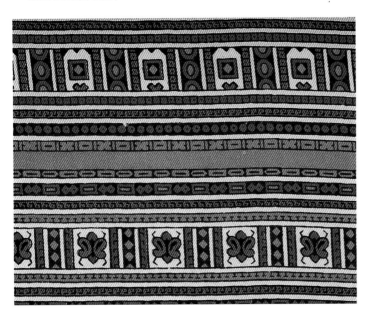

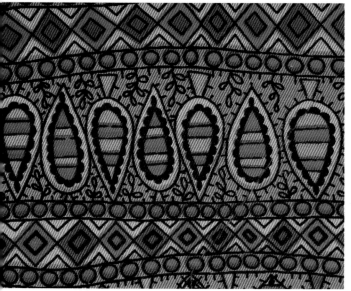

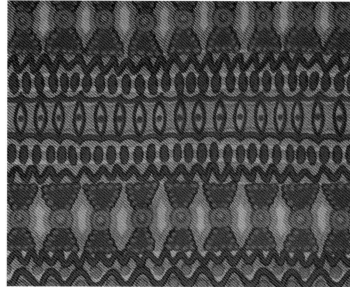

Silk. France. 1967.

Silk. France. 1967.

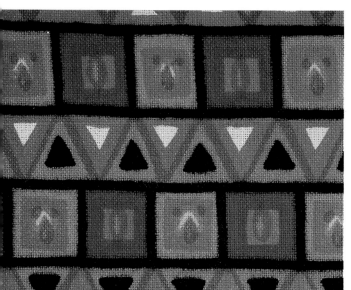

Cotton/polyester. France. 1963.

Silk. Italy. 1965.

Acetate. France. 1967.

Wool. Italy. 1968.

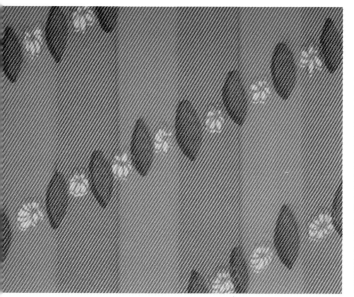

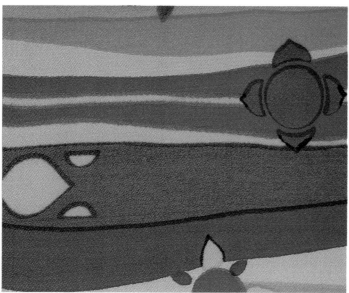

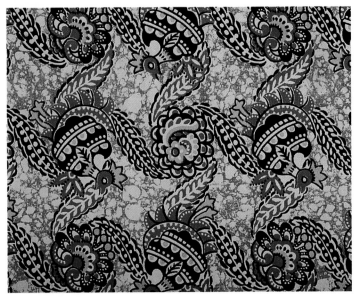

Cotton. USA. 1950s.

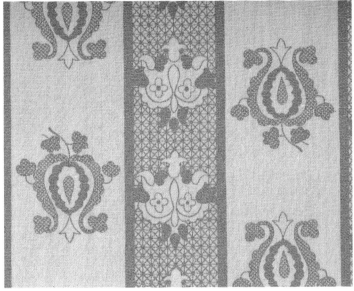

Rayon. France. 1963.

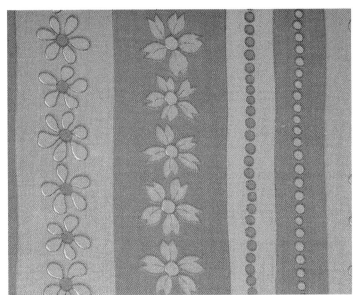

Cotton. France. 1963.
Silk. Italy. 1967.

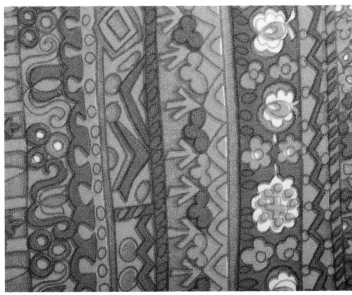

Viscose blend. France. 1966.
Cotton. France. 1963.

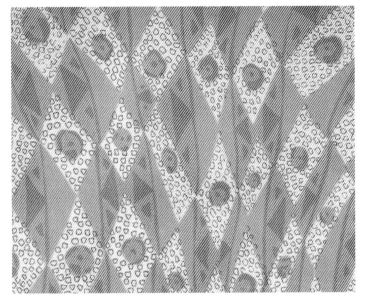

100

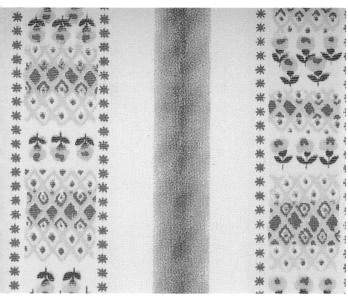

Cotton. France. 1967.

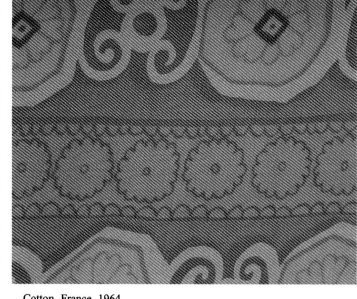

Cotton. France. 1964.

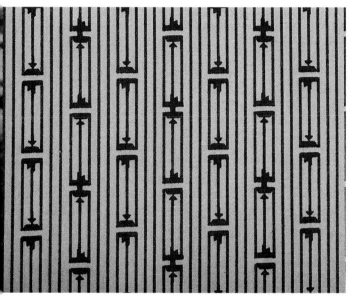

Cotton. USA. 1970.
Cotton. USA. 1948.

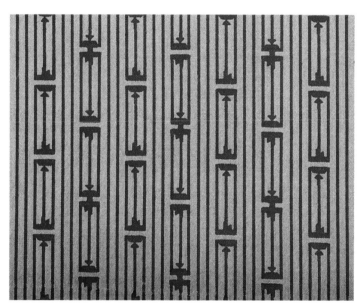

Cotton. USA. 1970.
Cotton. USA. 1948.

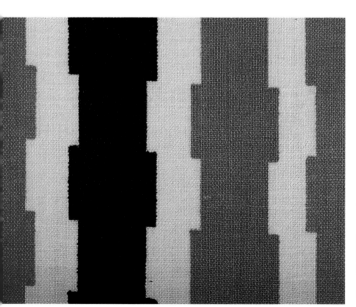

Cotton. France. 1963.

Cotton/polyester. France. 1962.

Cotton/polyester. France. 1964.

Polyester/acrylic/cotton. USA. 1980s.

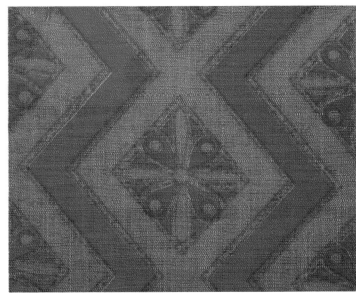

Silk/polyester. France. 1959.

Cotton/polyester. USA. 1980s.

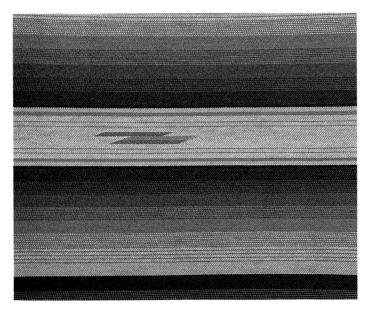

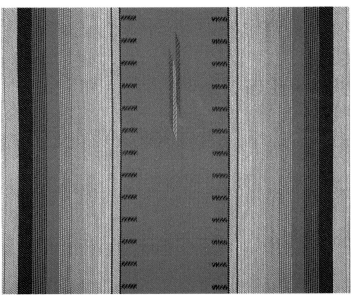

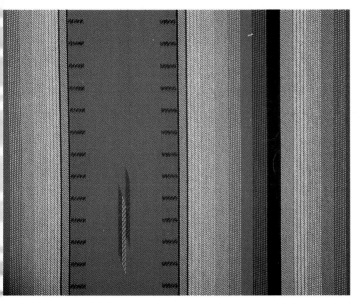

Cotton/polyester. USA. 1980s.

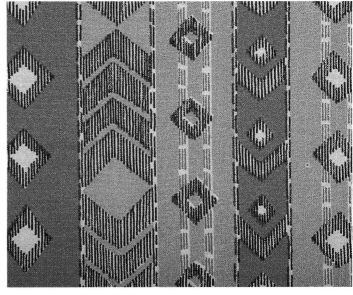

Cotton blend. France. 1966.

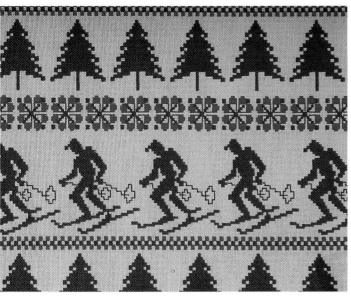

Cotton. USA. 1950s.

Nylon. France. 1966.

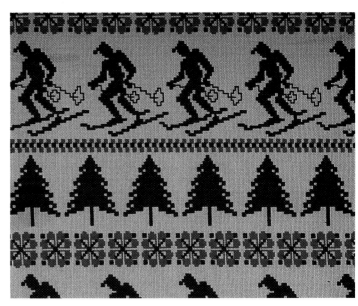

Cotton. USA. 1950s.

Cotton/rayon blend. France. 1955.

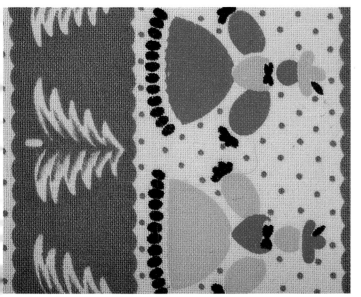

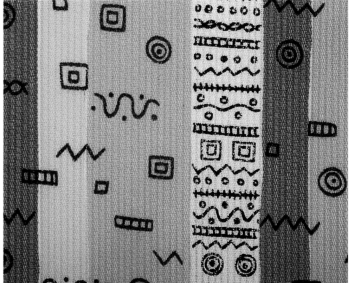

103

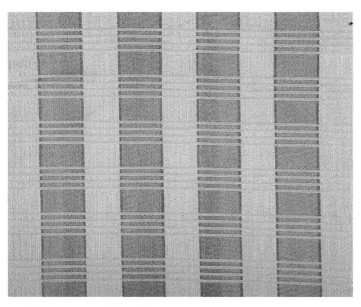

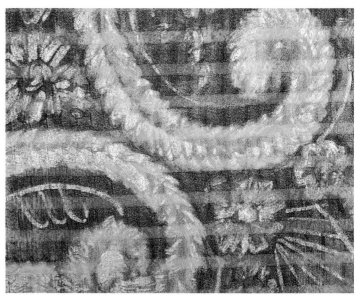

Polyester/rayon. USA. 1980s.

Rayon/polyester blend. France. 1966.

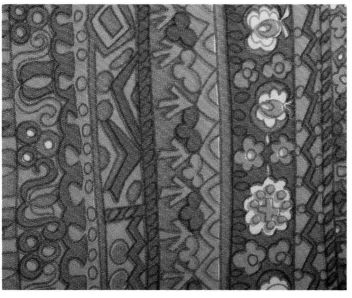

Silk blend. France. 1960s.
Cotton. France. 1962.

Silk. France. 1967.
Cotton. USA. 1942.

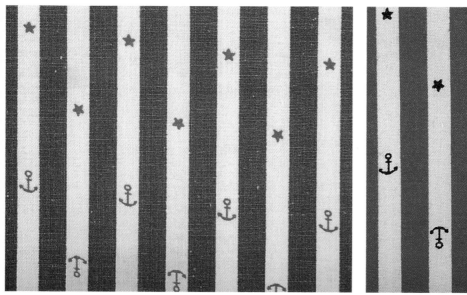

Cotton. USA. 1942.

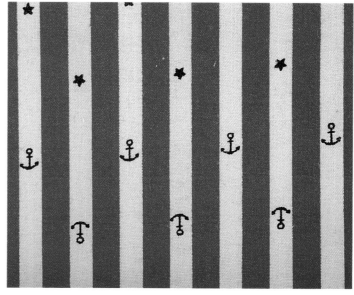

Cotton. USA. 1942.

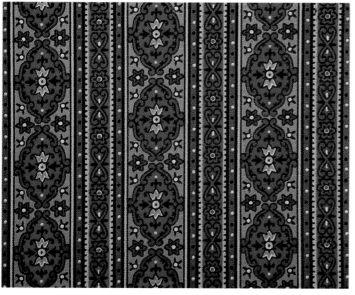

Cotton. USA. 1963.
Cotton. USA. 1963.

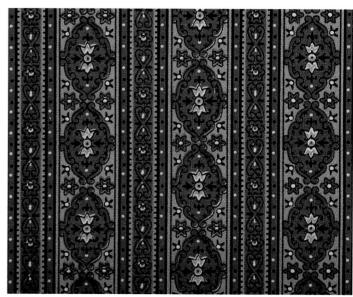

Cotton. USA. 1963.
Cotton. USA. 1963.

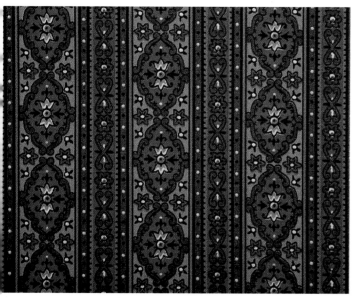

Rayon. France. 1963.

Cotton. USA. 1963.

Cotton. USA. 1963.
Cotton. France. 1959.

Cotton. USA. 1963.
Cotton. France. 1966.

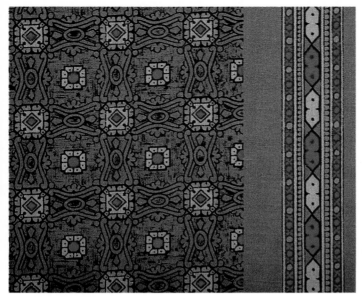

Cotton. USA. 1965.

Cotton. USA. 1965.

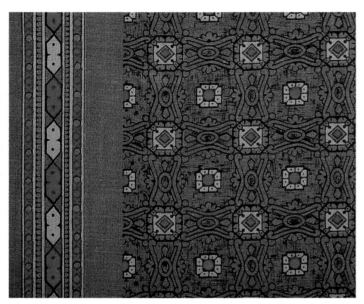
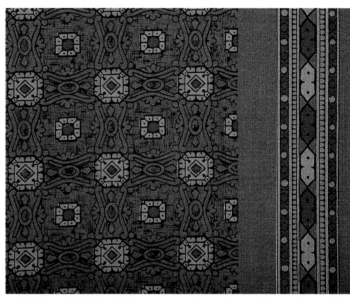

Cotton. USA. 1965.

Cotton. USA. 1965.

Cotton. USA. 1965.

Cotton. USA. 1965.

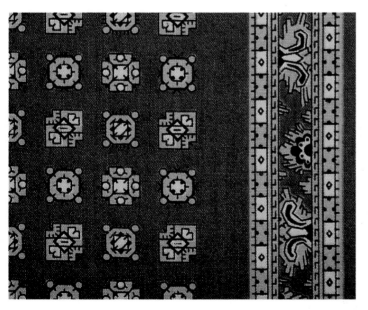
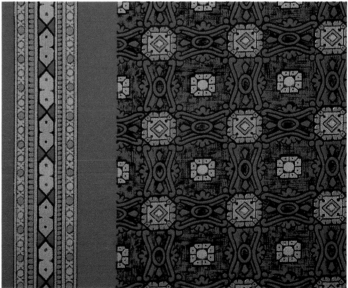

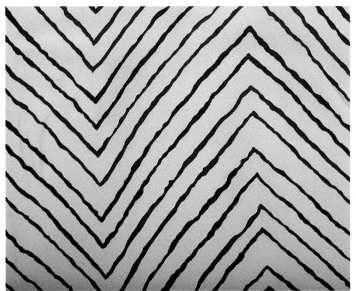

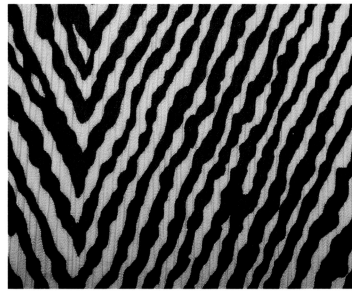

Silk. USA. 1950s.

Silk. USA. 1950s.

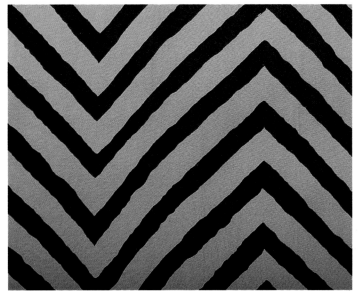

Silk. USA. 1950s.
Cotton. USA. 1950s.

Polyester. USA. 1950s.
Silk. France. 1963.

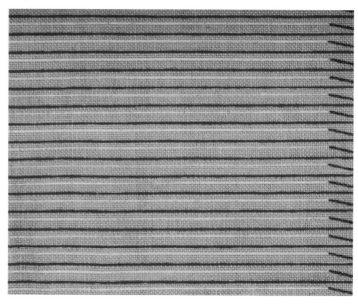

Cotton. France. 1950s.

Cotton. USA. 1950s.

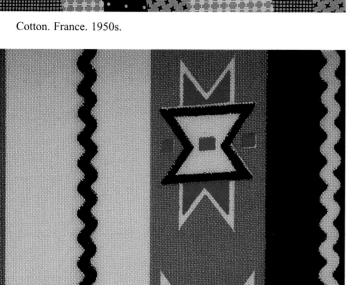

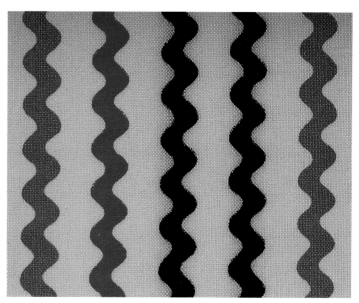

Cotton. USA. 1950s.
Cotton. USA. 1950s.

Cotton. USA. 1950s.
Cotton. USA. 1950s.

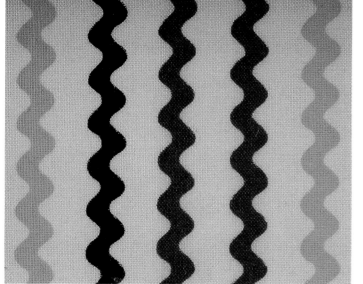

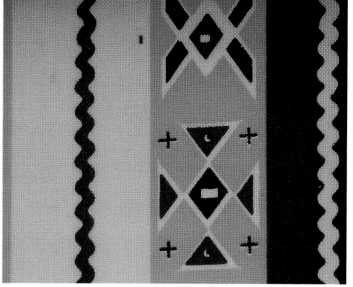

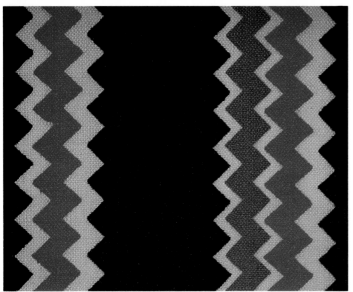

Cotton. USA. 1948.

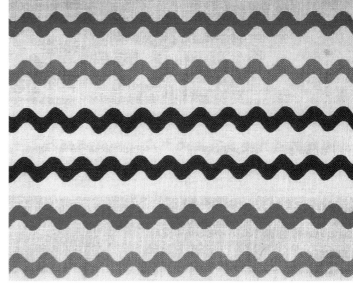

Cotton. USA. 1950s.

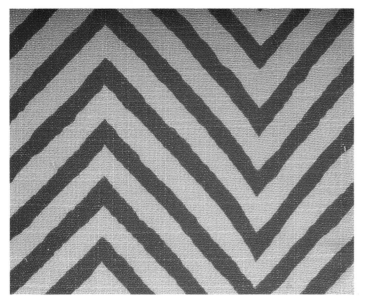

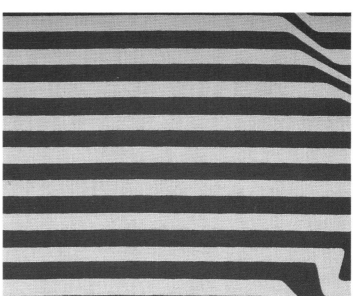

Open-weave cotton. USA. 1950s.

Cotton. France. 1950s.

Cotton. USA. 1948.

Cotton. USA. 1950s.

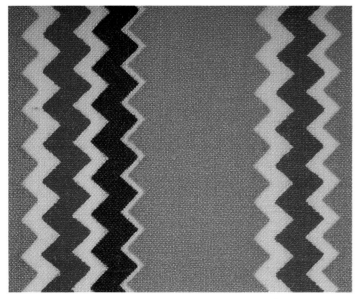

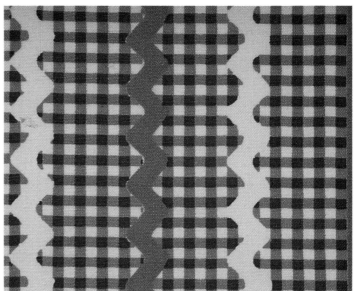

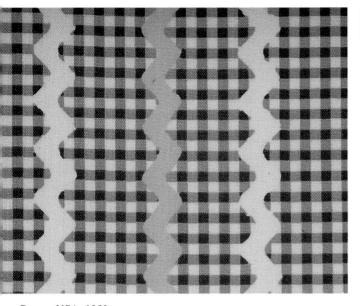

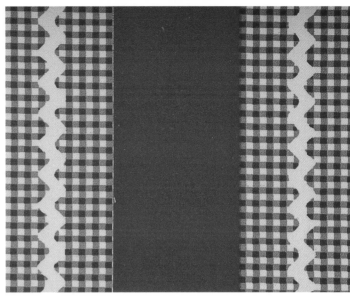

Cotton. USA. 1950s.

Cotton. USA. 1950s.

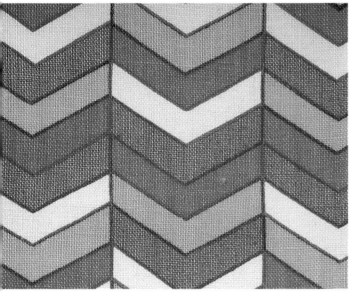

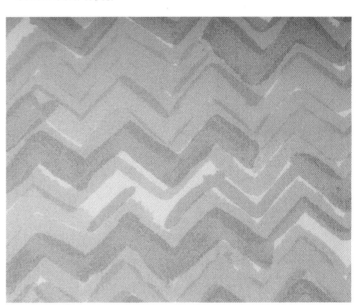

Cotton. Italy. 1965.

Silk/rayon blend. France. 1966.

Silk. France. 1966.

Silk. Italy. 1950s.

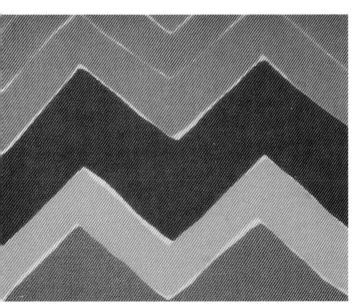

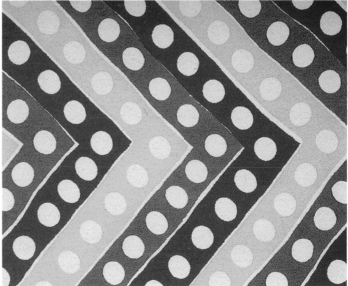

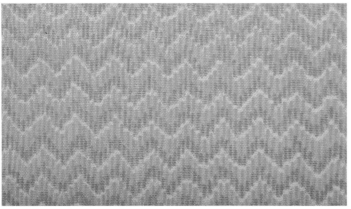

Nylon. France. 1966.

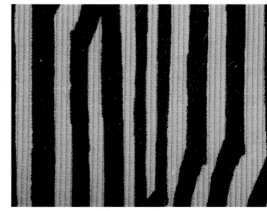

Cotton. France. 1954.

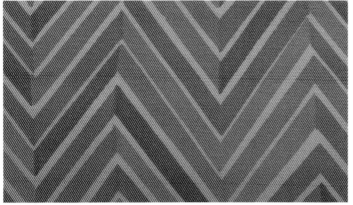

Silk. France. 1967.

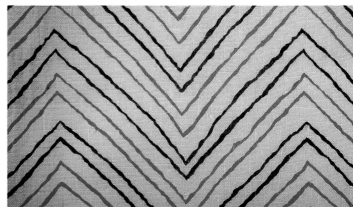

Cotton. USA. 1950s.

Mohair/rayon/cotton. France. 1966.

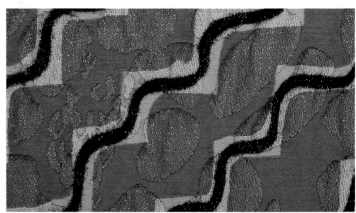

Polyester/nylon. France. 1967.

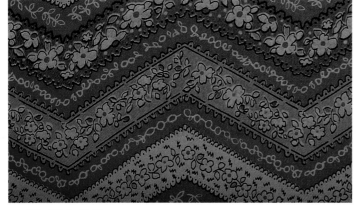

Silk. USA. 1950s.

Silk. France. 1967.